CLASSIC JAPANESE PORCELAIN

CLASSIC JAPANESE PORCELAIN

IMARI AND KAKIEMON

TAKESHI NAGATAKE

KODANSHA INTERNATIONAL
Tokyo • New York • London

FRONT JACKET: Imari bowl with mountain landscape design. Tokyo National Museum. Kakiemon octagonal covered jar with flowers and bird design. Idemitsu Museum of Arts.
BACK JACKET: Detail of Imari plate with "five ships" design. MOA Museum of Art.

Previously published separately as Imari (© 1982) and Kakiemon (© 1981).

Distributed in the United States by Kodansha America, Inc., 575 Lexington Avenue, New York, New York, 10022, and in the United Kingdom and continental Europe by Kodansha Europe Ltd., 95 Aldwych, London WC2B 4JF.

Published by Kodansha International Ltd., 17-14 Otowa 1-chome, Bunkyo-ku, Tokyo 112-8652 and Kodansha America, Inc.

www.thejapanpage.com

CONTENTS

MAP OF ARITA SARAYAMA

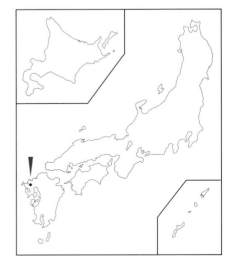

 Uchiyama

Sotoyama

Nishi-Arita

ZŌSHUKU

Ryūsen-ji temple

Arita River

Seiroku-no-Tsuji kiln site

Kakiemon family Lower Tombs

Komononari kiln site
Tenjin-no Mori kiln site

Nangawara-yama
Kakiemon kiln

Kakiemon family
Upper Tombs
Nabeshima fief kiln site

Higuchi kiln site
Temmoku kiln site

Sotoyama

Kakenodani kiln site
Ōbō kiln
Kuromuta kiln
Tōzan Shrine
Yamabeta kiln site
Maruo kiln site

Komizo kiln site

ARITA

Nabeshima fief kiln site
Iwayagawachi kiln site

Sarugawadani kiln site

Arita

Mt. Shirakawa

Tomb of Kanagae Sambei (Ri Sampei)
Tengudani kiln site

Uchiyama

Middle Shirakawa kiln site
Lower Shirakawa kiln site

Sarayama Kaisho

Izumiyama kiln site
Izumiyama

Tenjinyama kiln site
Hiekoba kiln site

Nishinobori kiln

Maenobori kiln site
KAMI-ARITA

Ōdaru kiln site
Hōon-ji temple

Akae-machi

Nakadaru kiln site

Imaemon kiln
Hōgen-ji temple

Tōzan Shrine

Kodaru kiln site
Hyakkengama kiln site

Mt. Rengeishi

Mt. Kanayama

Yamauchi

Ōsotoyama

INTRODUCTION

Ever since kaolin was discovered in the Hizen area of Kyūshū in the early seventeenth century, the area has been famous for its beautiful porcelain. A wide range of wares decorated in cobalt blue underglaze or colorful overglaze enamels were shipped to Europe by the Dutch East Indies Company. In this volume, the late Takeshi Nagatake, possibly the most knowledgeable scholar on the subject, discusses the developments in techniques, styles, designs and trade of these exquisite wares.

The hub of porcelain production in the seventeenth through nineteenth centuries was the province of Hizen in Kyūshū, the southernmost of Japan's four main islands, which is now part of Saga and Nagasaki prefectures. The majority of the porcelain-producing kilns in Hizen province were concentrated in an area known as Arita Sarayama, which was under the control of the Nabeshima fief. The specialized *aka-e* enamellers were based in Arita Sarayama's eastern Uchiyama sector, while the less specialized workshops were in the Sotoyama sector to the west. Some wares were also produced in the Ōsotoyama sector in the Saga fief to the southeast of Arita.

Wares from the area generally came to be known as Imari, after the name of the nearby port from which they were shipped. One family of potters and kiln owners gained particular prominence for the beauty and quality of their wares: the Sakaida Kakiemon family. The Kakiemon tradition was started in around 1623 or 1624 by Sakaida Kizaemon, also known as Kakiemon I, and the family continues to produce porcelain today, headed by Kakiemon XIII. The Kakiemon workshops were based in the Nangawara-yama district of Arita Sarayama. This volume reveals the distinction in style between "pure Imari" and "pure Kakiemon," and the influence each had on the other.

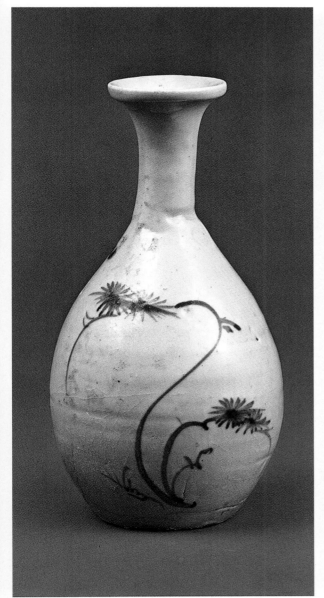

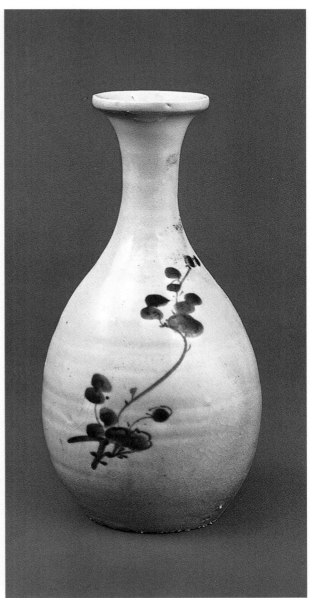

1

2

1. *Cobalt underglaze decorated bottle; pine tree design. H. 22 cm. Arita Ceramics Museum.*

2. *Cobalt underglaze decorated bottle; plum blossom design. H. 21.7 cm. Arita Ceramics Museum.*

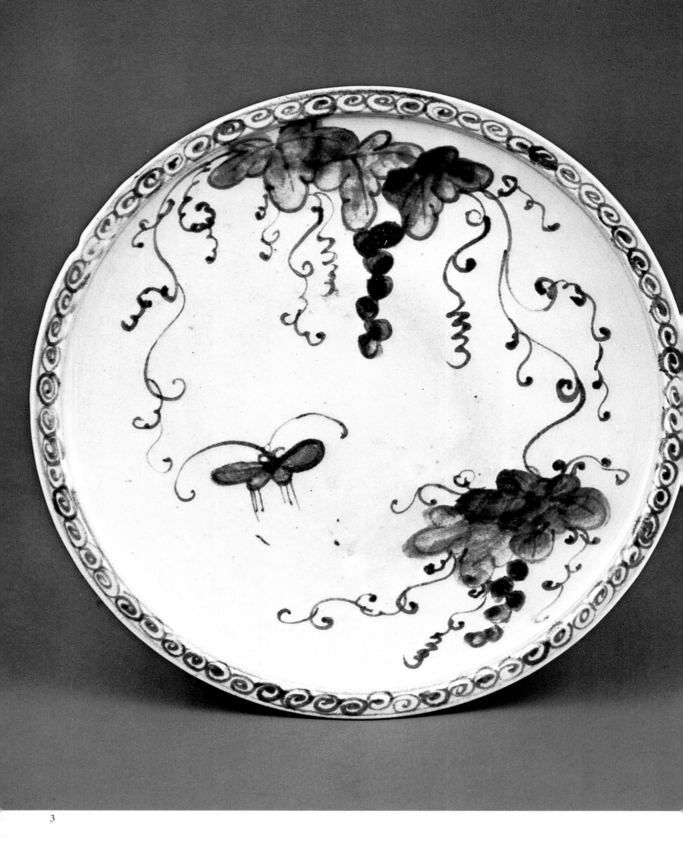

3

3. *Cobalt underglaze decorated dish; grapevine and butterfly design. D. 18.8 cm. Saga Prefectural Museum.*

4. *Cobalt underglaze decorated plate; bird and chrysanthemum scroll design. D. 21.3 cm.*

5. *Cobalt underglaze decorated foliate bowl; floral scroll design. D. 33.5 cm. Idemitsu Museum of Arts.*

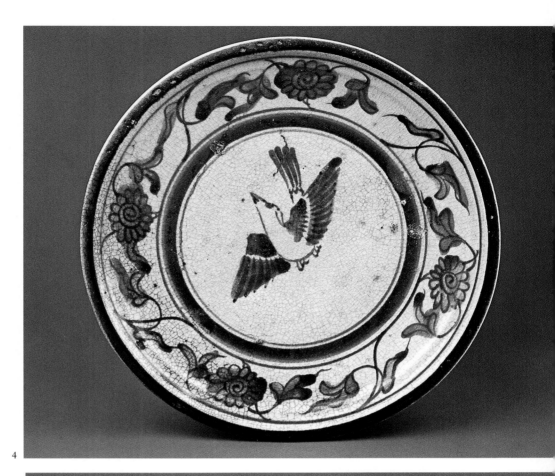

4

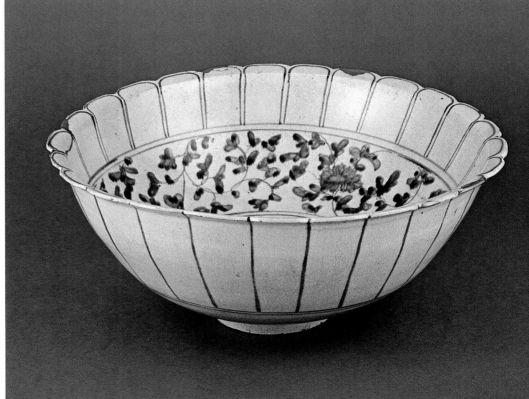

5

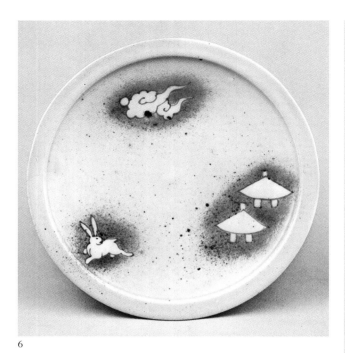

6

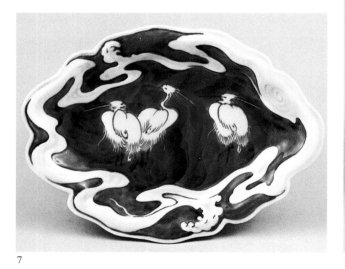

7

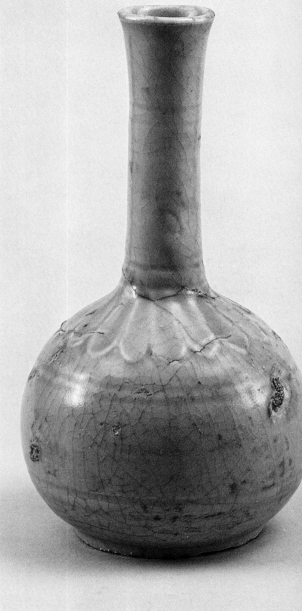

8

6. *Cobalt underglaze decorated dish; rabbit design in spray glaze* (fukisumite). *D. 19.3 cm. Imaemon Antique Ceramics Center.*

7. *Azure-glazed dish; white heron design. 17 cm x 12.2 cm. Kamachi Collection.*

8. *Celadon bottle; incised floral design. H. 20.2 cm. Arita Ceramics Museum.*

9. *Cobalt underglaze decorated fluted bottle; floral design in panels. H. 31.5 cm. MOA Museum of Art.*

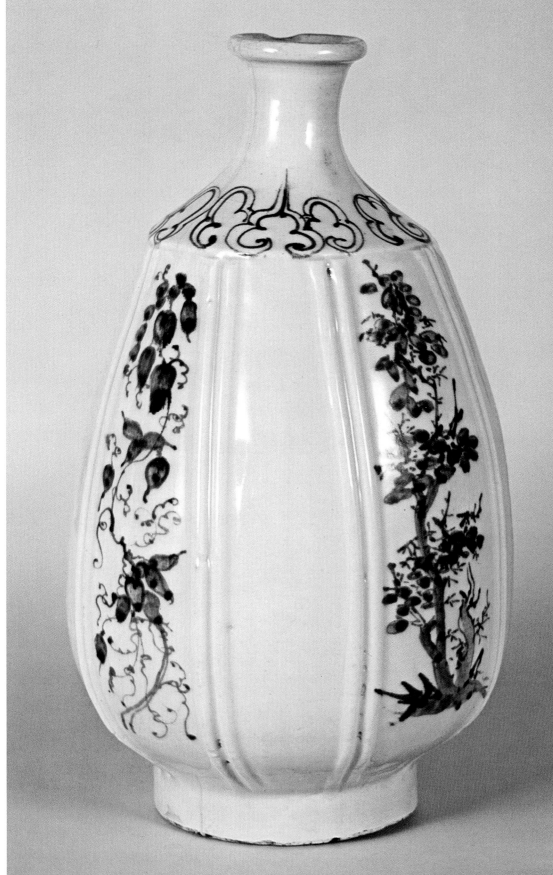

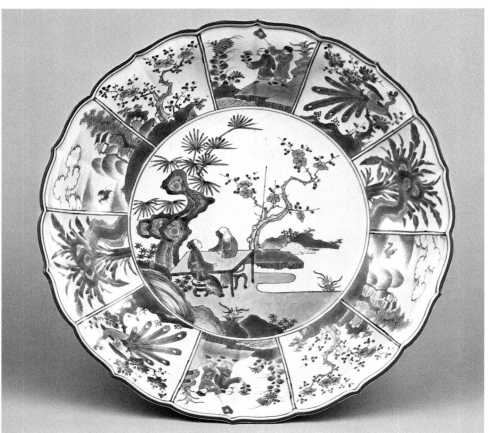

10

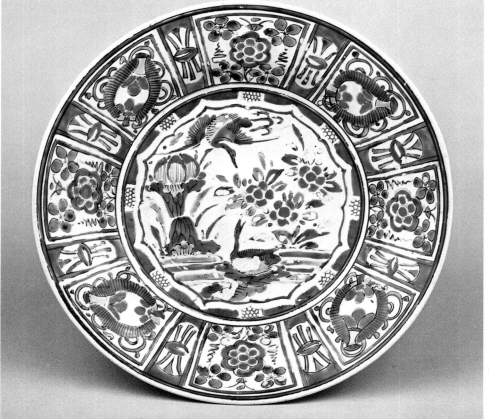

11

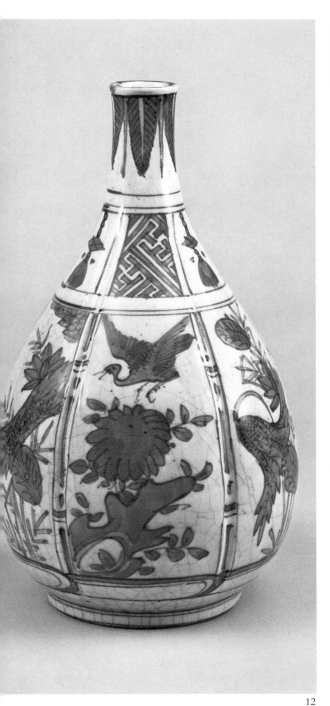
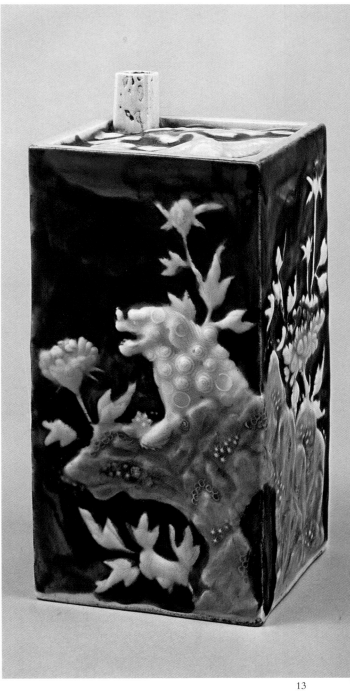

12

13

10. *Cobalt underglaze decorated foliate dish; flower, bird, and Chinese literati design. D. 38 cm. Kamachi Collection.*

11. *Polychrome enameled flat dish; bird-and-flower design. D. 31.1 cm. Kurita Art Museum.*

12. *Cobalt underglaze decorated bottle; bird-and-flower design in six panels. H. 27.5 cm. Idemitsu Museum of Arts.*

13. *Azure-glazed square bottle; rock, peony, and shishi lion relief design. H. 20.3 cm.*

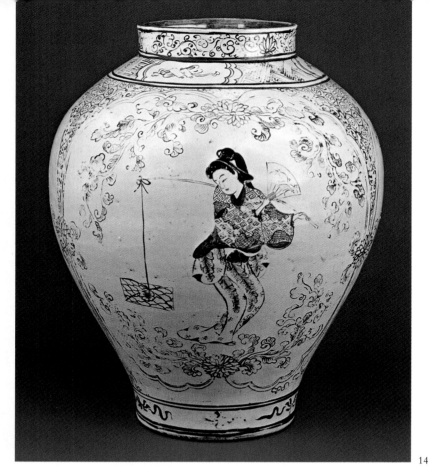

14

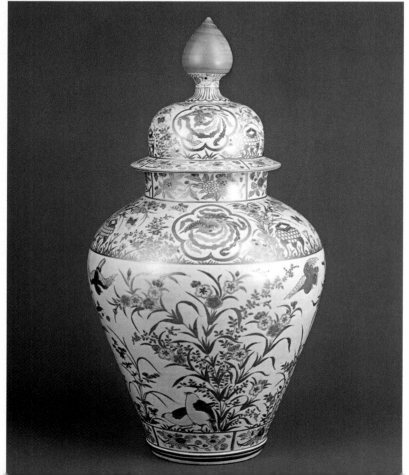

15

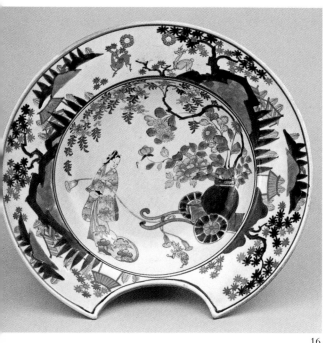

16

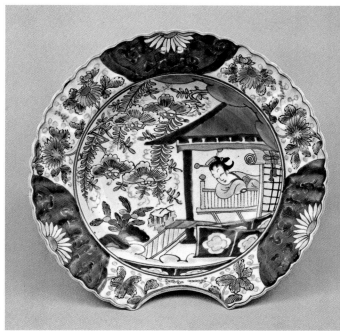

17

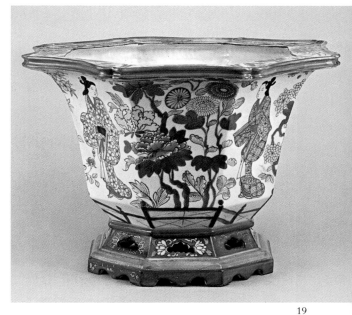

18

19

14. *Large overglaze enameled vase; design in three panels of popular customs. H. 38.5 cm. Tanakamaru Collection.*

15. *Large two-toned overglaze enameled vase; bird-and-flower design. H. 60.5 cm. Kamachi Collection.*

16. *Polychrome enameled shaving dish; genre design. D. 28.1 cm. Saga Prefectural Museum.*

17. *Polychrome enameled shaving dish; genre design. D. 27.6 cm. Kurita Art Museum.*

18. *Polychrome enameled shaving dish; genre design. D. 30.6 cm. Tanakamaru Collection.*

19. *Polychrome enameled vessel; chrysanthemum, peony, and genre design. H. 27 cm. Kanbara Collection, Arita Historical Museum.*

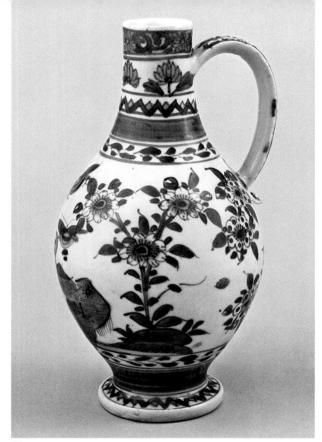

20

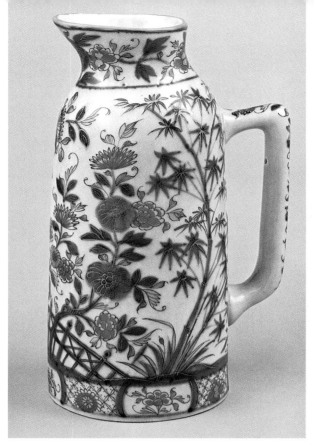

21

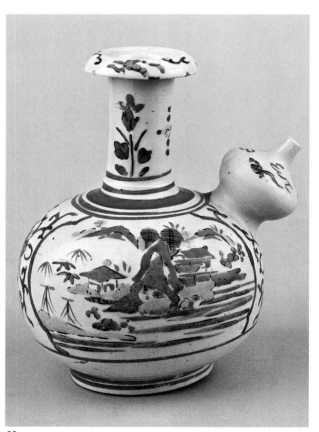

22

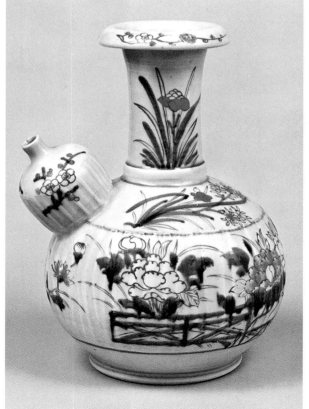

23

20. *Cobalt underglaze decorated jug; floral design. H. 23 cm. Kamachi Collection.*

21. *Polychrome enameled jug; bamboo, grass, and flower design. H. 24 cm. Kamachi Collection.*

22. *Polychrome enameled ewer; landscape design. H. 20.8 cm. Imaemon Antique Ceramics Center.*

23. *Polychrome enameled ewer, floral design. H. 21 cm. Kurita Art Museum.*

24. *Polychrome enameled lidded container with handles; chrysanthemum design. H. 17.5 cm. Arita Ceramics Museum.*

25. *Polychrome enameled lidded bowl and saucer; flower and bird design. H. 21 cm; saucer, D. 33.3 cm. Kanbara Collection, Arita Historical Museum.*

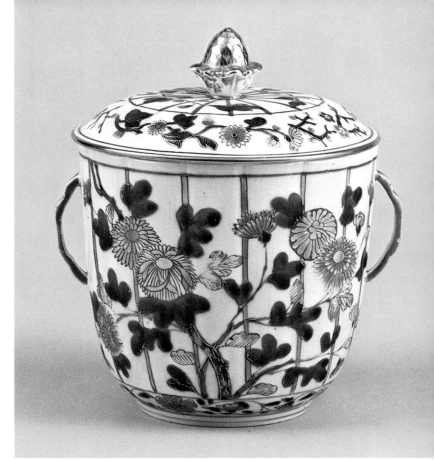

24

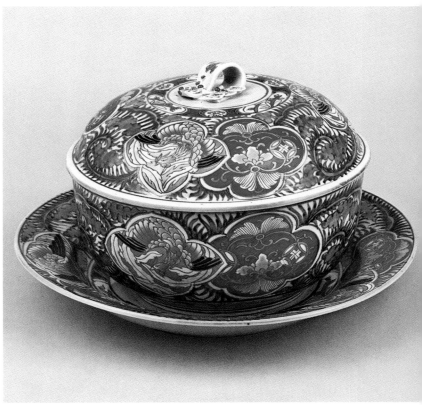

25

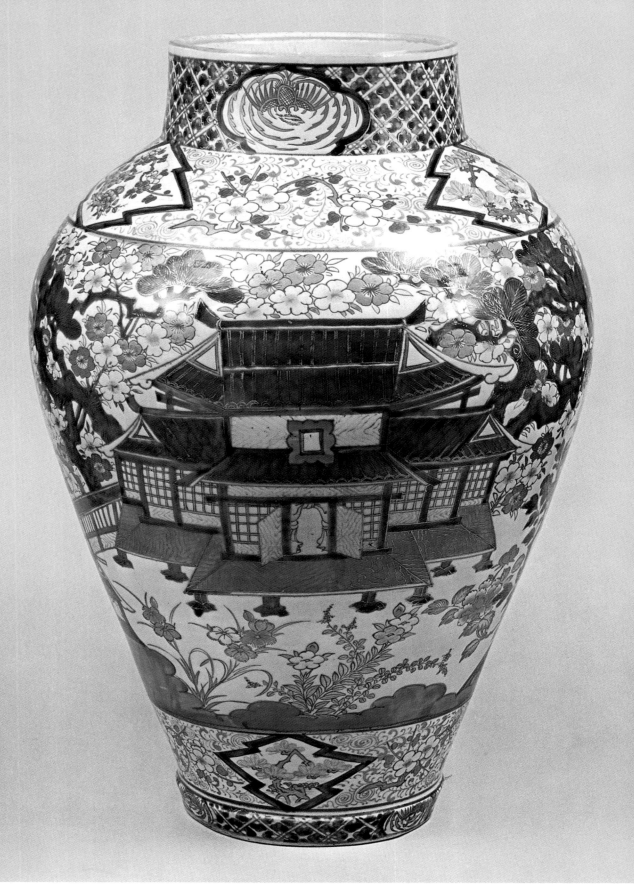

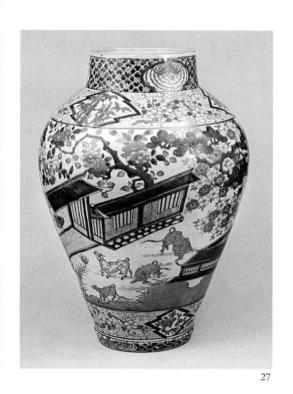

27

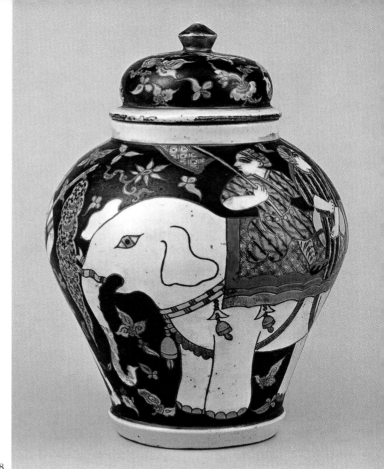

28

26., 27. *Large polychrome enameled jar; Dazaifu design. H. 59.7 cm. Genemon Pottery Center.*

28. *Polychrome enameled lidded jar; nanban ("Southern Barbarian") design. H. 24 cm. Kobe Municipal Museum of Nanban Art.*

29. *Polychrome enameled faceted jar; genre design. H. 35 cm.*

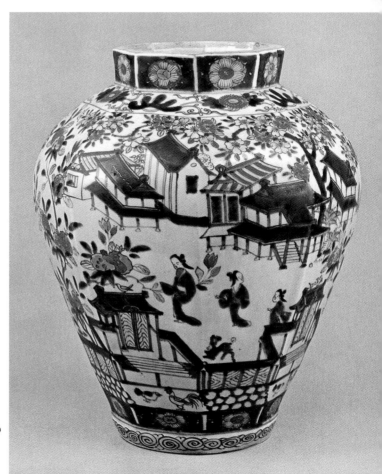

29

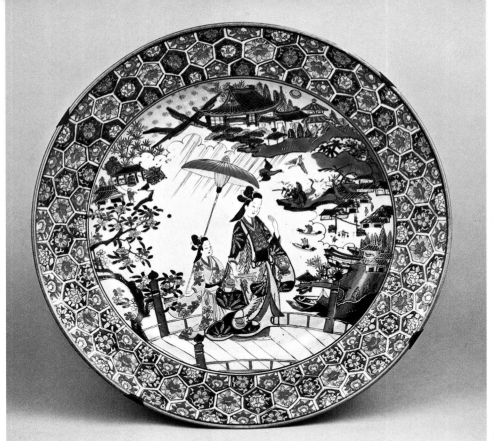

30

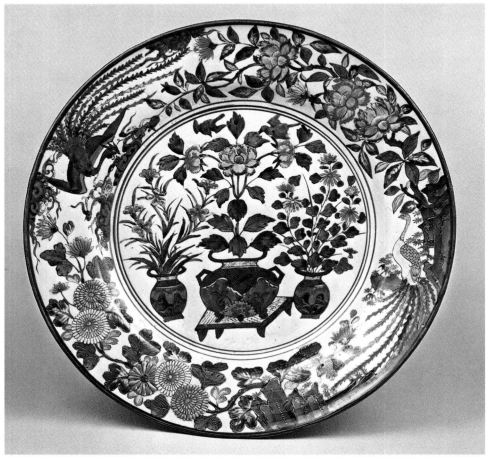

31

22

30. *Large polychrome enameled dish; courtesan and "Eight Views of Ōmi" design. D. 41.5 cm. Kanbara Collection, Arita Historical Museum.*

31. *Large polychrome enameled flat dish; basket of flowers and bird design. H. 54.8 cm. Kanbara Collection, Arita Historical Museum.*

32. *Polychrome enameled dish; streamers (noshi) and arrow design. 30.5 x 19.4 cm. Tanakamaru Collection.*

33. *Large polychrome enameled lidded jar; flower-and-bird design. H. 47 cm. Kurita Art Museum.*

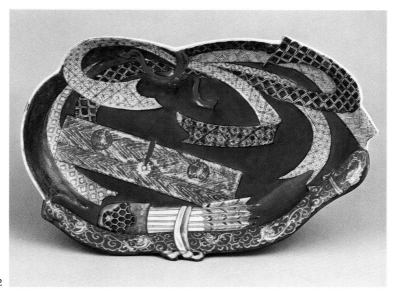

32

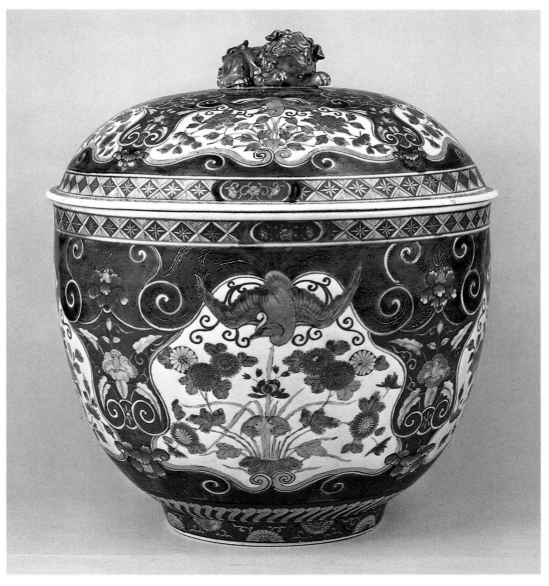

33

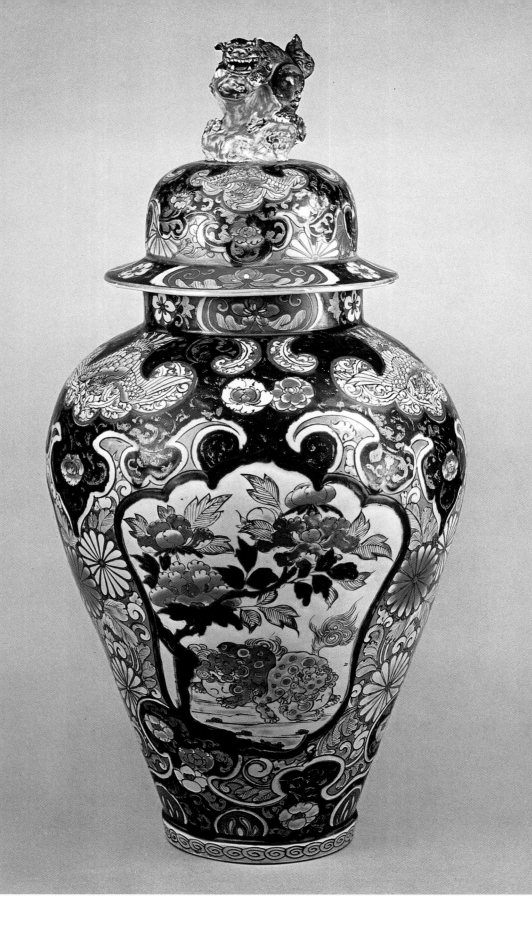

34. *Large polychrome enameled vase; peony,* shishi *lion, and sacred bird design. H. 82 cm. Kanbara Collection, Arita Historical Museum.*

35. *Polychrome enameled lampstands; flower basket design. Left, H. 59 cm. Kanbara Collection, Arita Historical Museum.*

36. *Polychrome enameled bowl; "five ships" design. D. 36.4 cm. MOA Museum of Art.*

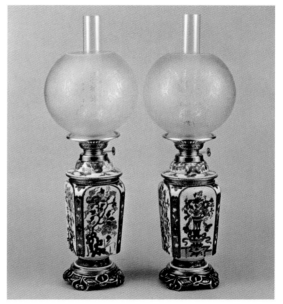

35

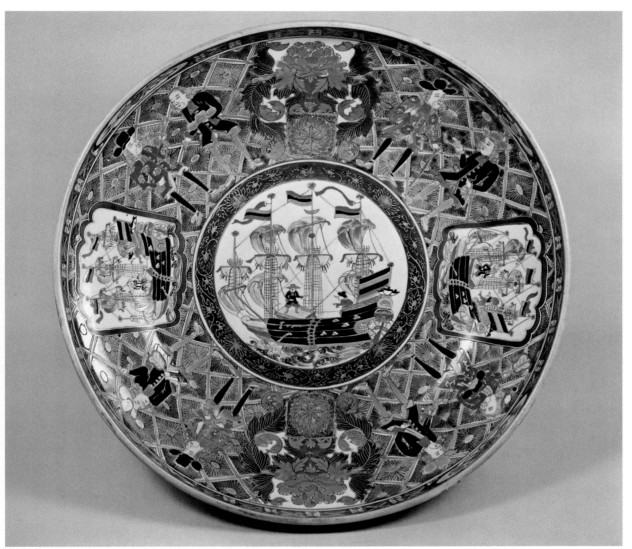

36

37

38

39

37. *Cobalt underglaze decorated bowl; foxtail millet and quail design. D. 20.8 cm.*

38. *Cobalt underglaze decorated plate; pine tree and crane design. D. 22.3 cm.*

39. *Polychrome enameled oil jars. Back left, H. 5 cm, D. 9.1 cm. Front left, H. 6.2 cm, D. 9.6 cm.*

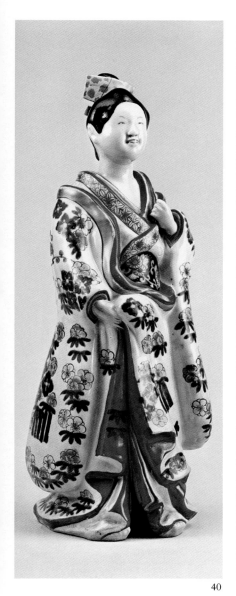

40

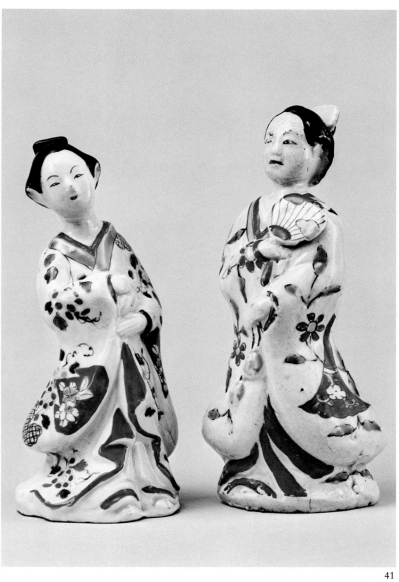

41

40. *Polychrome enameled figurine. H. 46.5 cm.*

41. *Pair of polychrome enameled figurines. Left, H. 18 cm. Kanbara*
 Collection, Arita Historical Museum.

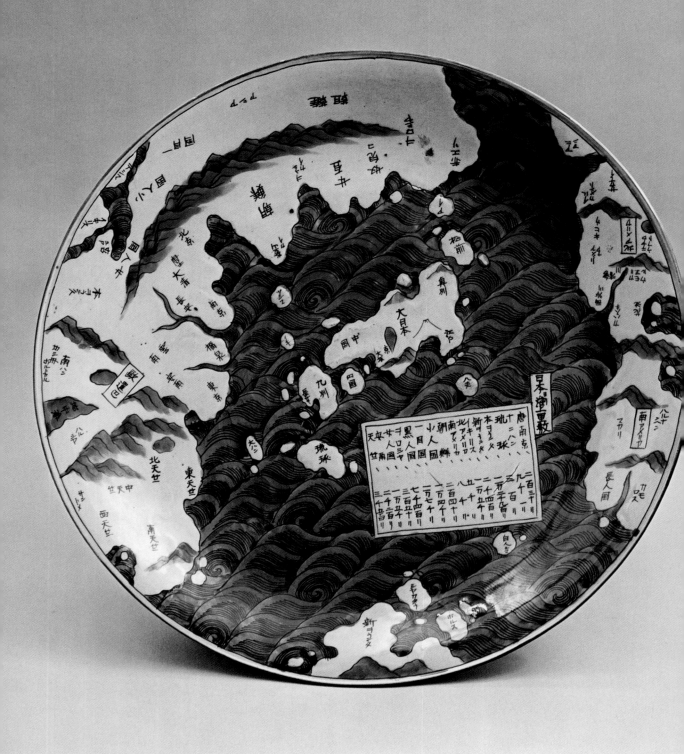

42

42. *Large cobalt underglaze decorated plate; map of East Asia. D. 52.1 cm. Saga Prefectural Museum.*

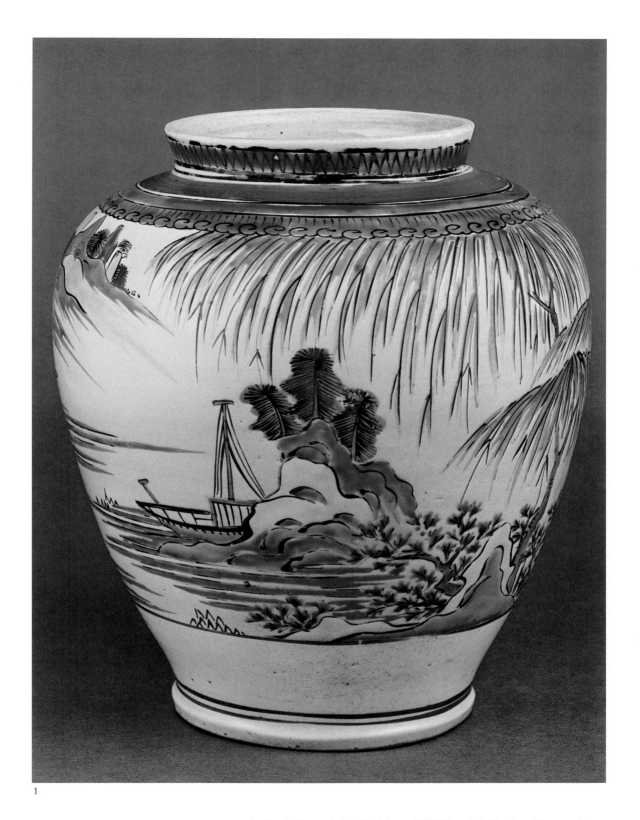

1. *Jar; landscape design. H. 26 cm. Mid-Edo period. Idemitsu Museum of Arts.*

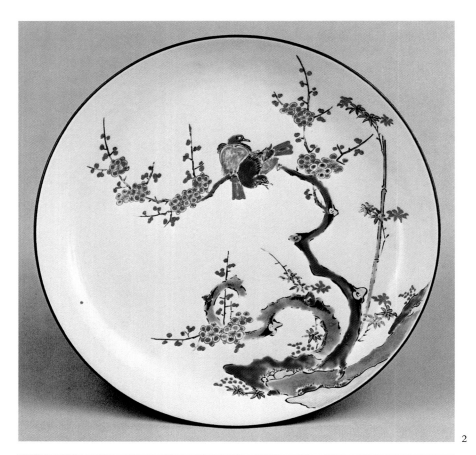

2

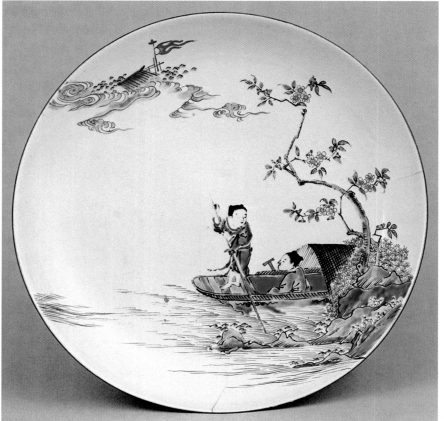

3

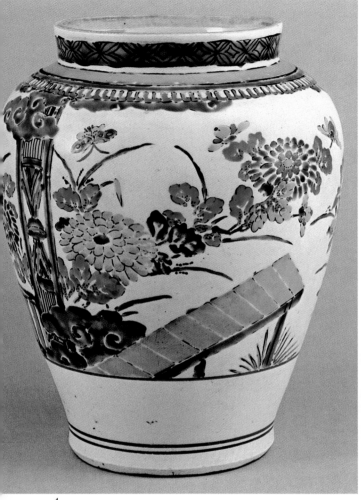

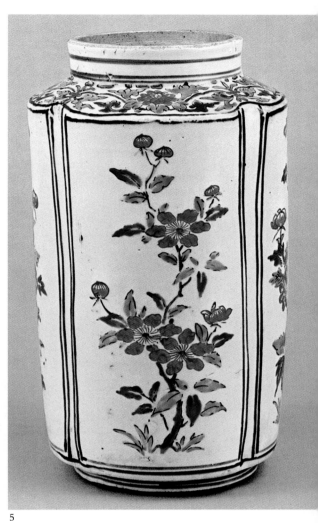

4

5

2. *Dish; bamboo, plum, and bird design. D. 24.8 cm. Early Edo period.*

3. *Dish; boating design. D. 23.1 cm. Early to mid-Edo period. Tanakamaru Collection.*

4. *Jar; flower and butterfly design in three panels. H. 22.2 cm. Early Edo period. Saga Prefectural Museum.*

5. *Jar; flowering grasses design in four panels. H. 25.5 cm. Kakiemon Collection.*

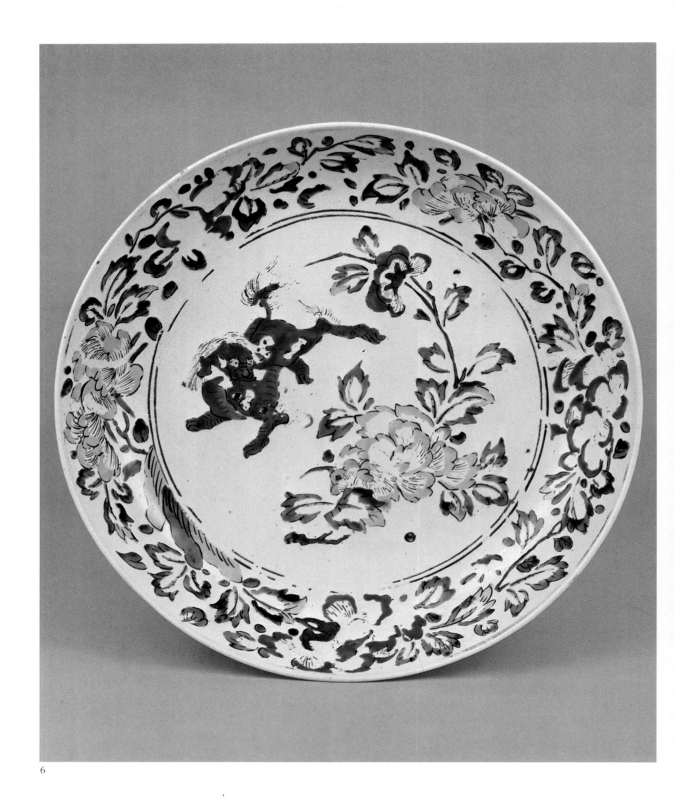

6. *Dish;* shishi *lion and peony design. D. 27.3 cm. Early Edo period. Kamachi Collection.*

7. *Three-legged candlestick; wisteria design. H. 33 cm. Mid-Edo period. Tanakamaru Collection.*

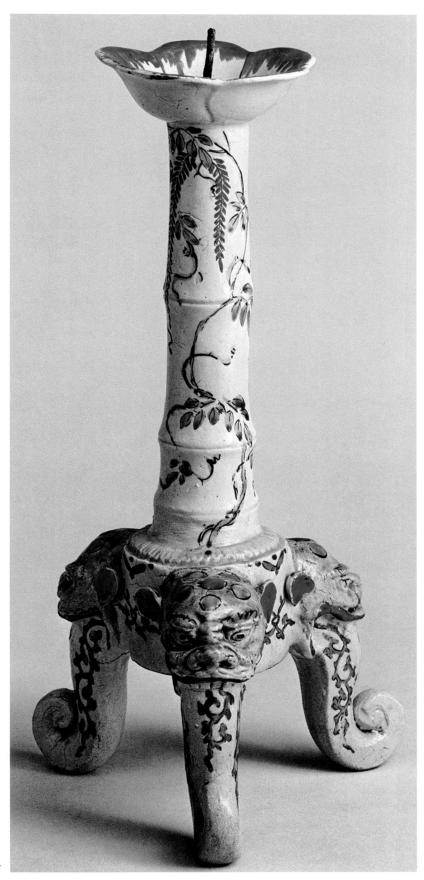

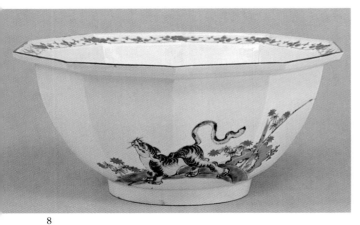

8

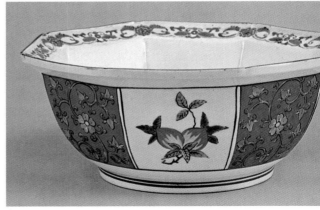

9

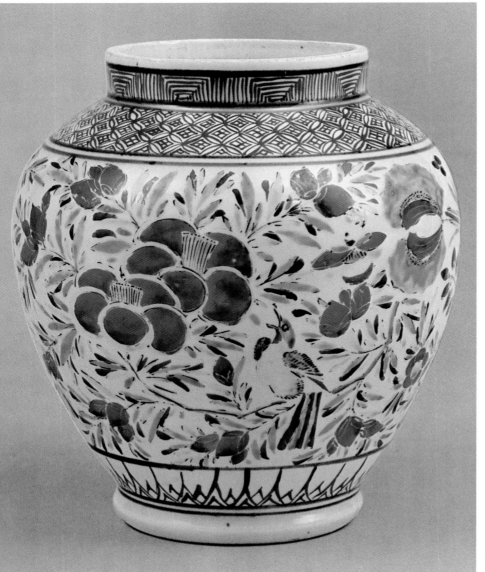

10

8. *Decagonal bowl; bamboo and tiger design. D. 23 cm. Mid-Edo period. Tanakamaru Collection.*

9. *Octagonal bowl; peach and floral scroll design. D. 21.3 cm. Mid-Edo period. Tanakamaru Collection.*

10. *Jar; flower-and-bird design. H. 16 cm. Mid-Edo period.*

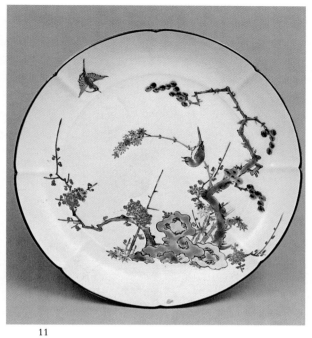

11

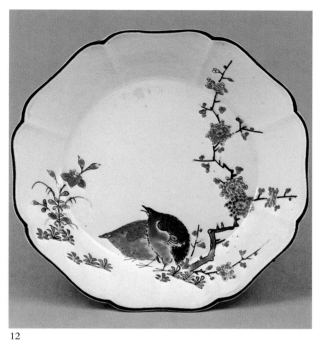

12

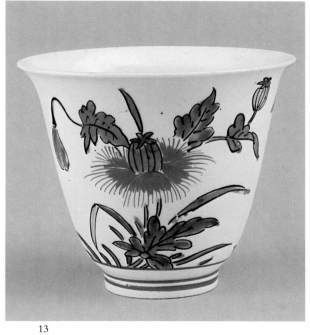

13

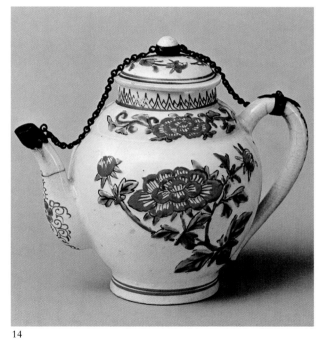

14

11. *Dish; pine-bamboo-plum and bird design.
 D. 21.8 cm. Kakiemon Collection.*

12. *Dish; plum and quail design. D. 13.2 cm.
 Saga Prefectural Museum.*

13. *Small deep bowl; poppy design. D. 9.8 cm.*

14. *Ewer, peony design. H. 15.3 cm.*

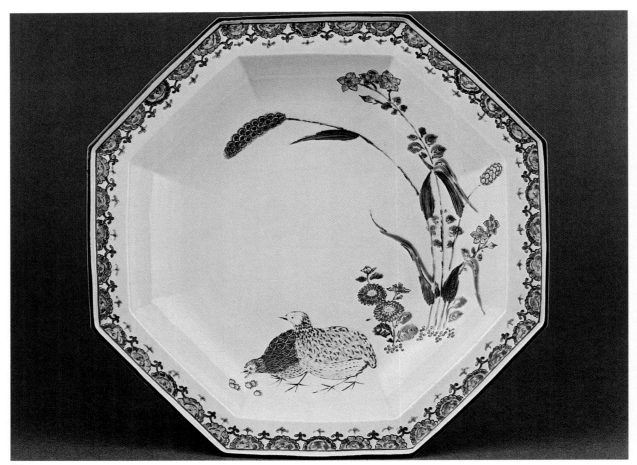

15

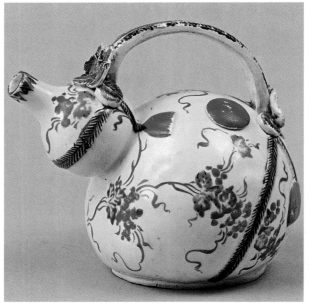

16

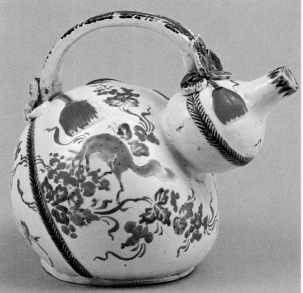

17

15. *Octagonal bowl; millet and quail design with border band of halved floral roundels. D. 22.3 cm. Idemitsu Museum of Arts.*

16., 17. *Gourd-shaped ewer; grape and squirrel design. H. 16.3 cm.*

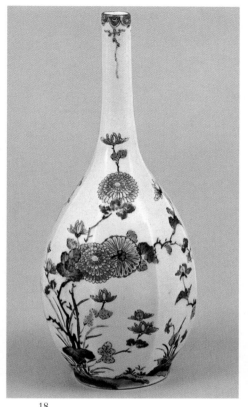

18

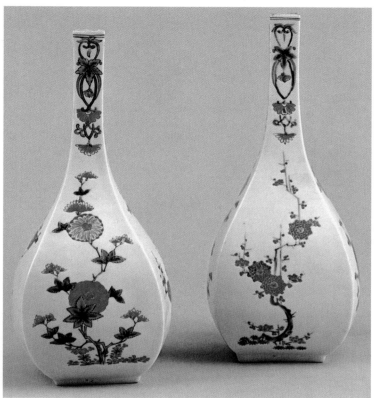

19

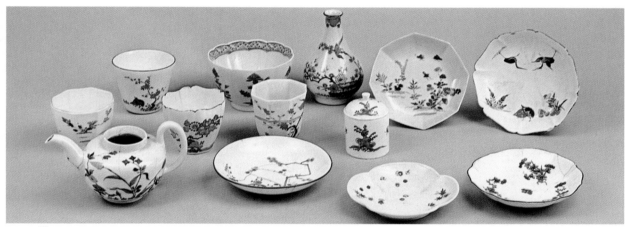

20

18. *Narrow-necked hexagonal bottle; rock and chrysan-*
 themum design. H. 23.3 cm. Saga Prefectural
 Museum.

19. *Narrow-necked square bottles; plum and chrysan-*
 themum designs. Left, H. 21.5 cm. Kakiemon
 Collection.

20. *European copies of Kakiemon style polychrome*
 overglaze enameled wares. H. 1.8–11.8 cm, D.
 5.1–22.5 cm. Saga Prefectural Museum.

21. *Dish; grape and squirrel design. Meissen porcelain.*
 D. 20.5 cm.

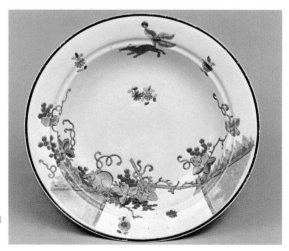

21

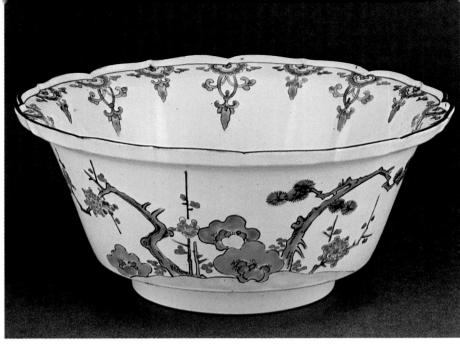

22. *Foliate bowl; pine-bam-boo-plum design and border band with floral pattern. D. 17.1 cm. Idemitsu Museum of Arts.*

23. *Jar; flower-and-bird designs in three panels. H. 25.9 cm. Idemitsu Museum of Arts.*

22

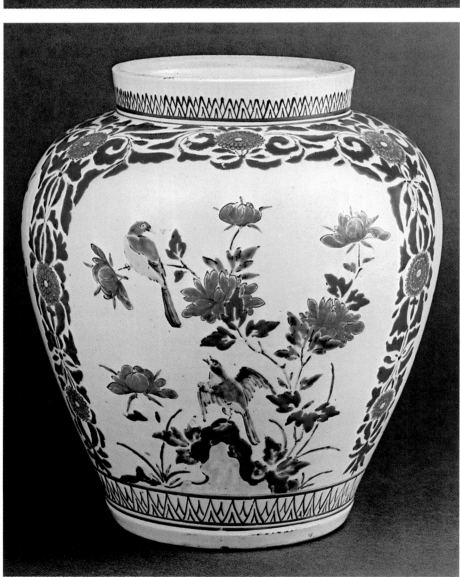

23

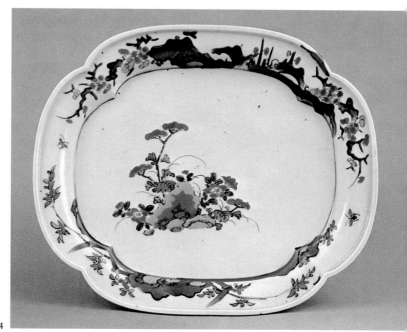

24

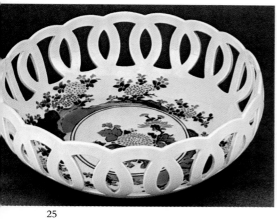

25

24. *Lobed dish; rock and autumn grasses design.*
21.2 cm x 18.4 cm. Mid-Edo period.
Tanakamaru Collection.

25. *Bowl; chrysanthemum and peony design with*
openwork border of linked circles. D. 25.8
cm. Idemitsu Museum of Arts.

26. *Pair of narrow-necked bottles; brushwood*
fence, flower, and bird design. Left, H. 25 cm.

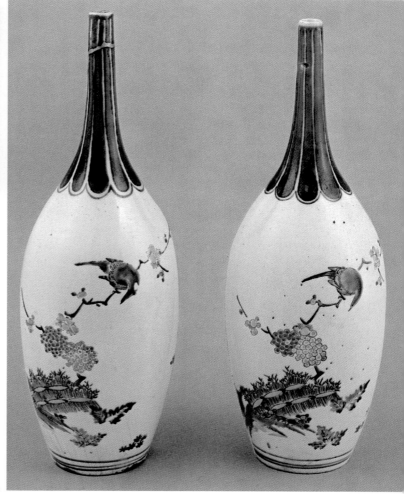

26

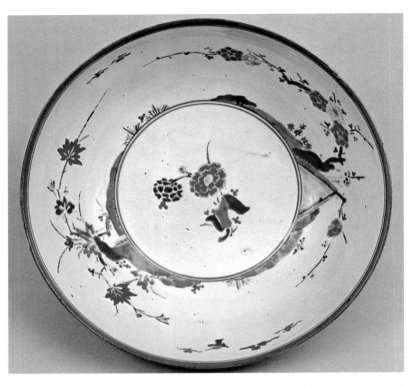

27

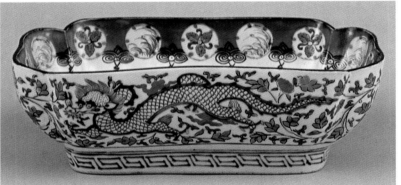

28

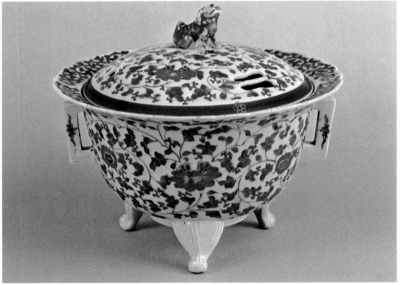

29

27. *Bowl; plum and flowering grass design. D. 26 cm.*

28. *Rectangular bowl; dragon and phoenix design. H. 5 cm.*

29. *Incense burner; floral scroll design. H. 15 cm.*

30

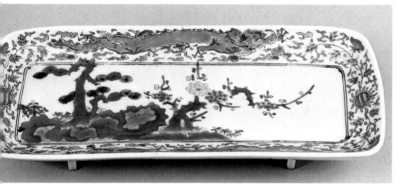

31

32

30. *Incense burner; maple leaf and stream design. Wagtail-shaped incense box. Left, H. 6.4 cm. Mid-Edo period.*

31., 32. *Footed rectangular dish; pine-bamboo-plum design. 21.8 cm x 9.5 cm.*

33. *Dish; flower-and-bird design. D. 18.5 cm. Kamachi Collection.*

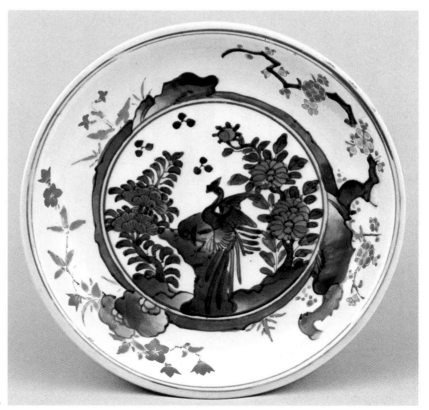

33

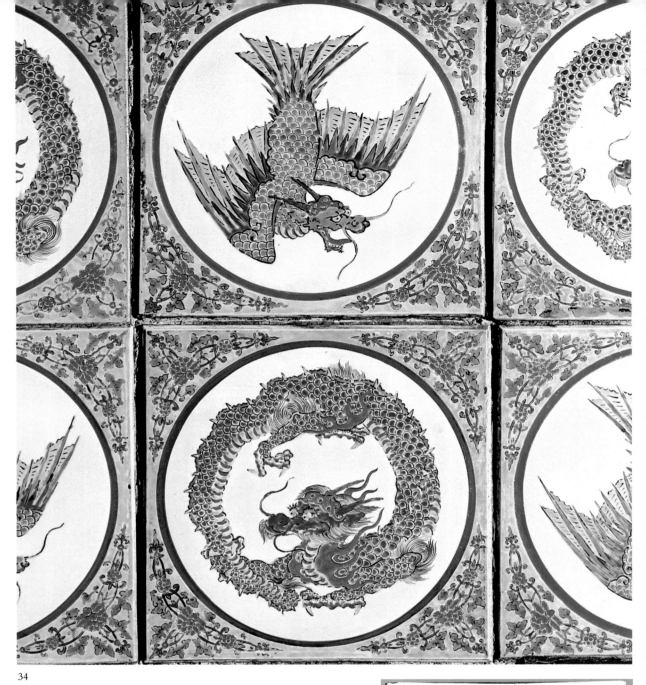

34

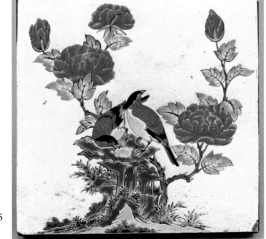

34. *Wall tiles; dragon design. Each tile 24.7 cm². Early Edo period.*
 Repository, Nishi-Honganji Temple.

35. *Tile; rock and bird design. 18 cm x 17.7 cm. Tanakamaru*
 Collection.

35

36. *Two-tiered lidded box in the shape of an insect cage; flowing plant design. H. 19.5 cm.*

37. *Jar; flower-and-bird design. H. 28.7 cm.*

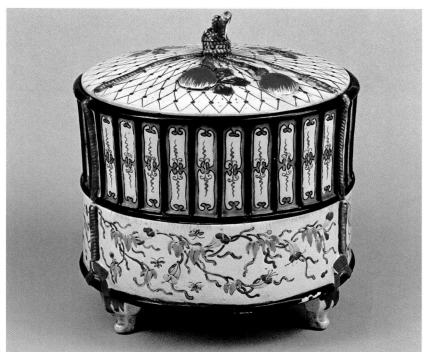

36

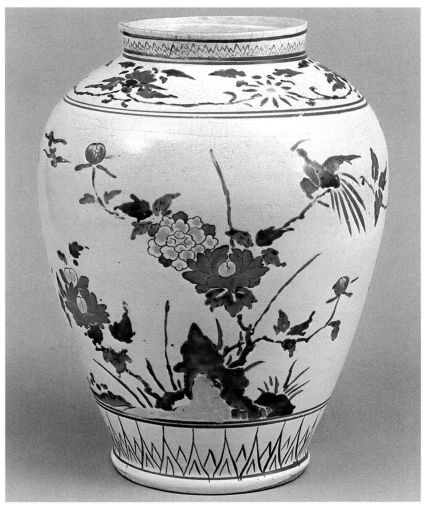

37

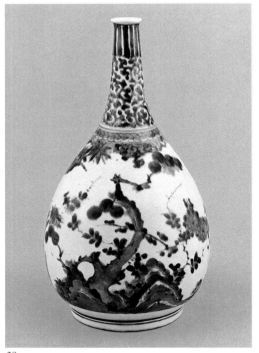

38

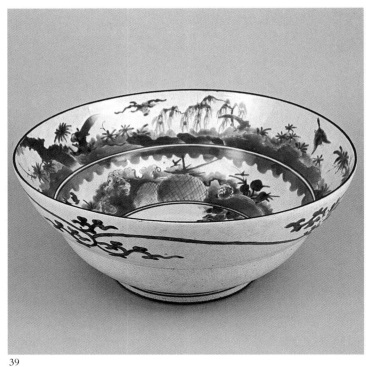

39

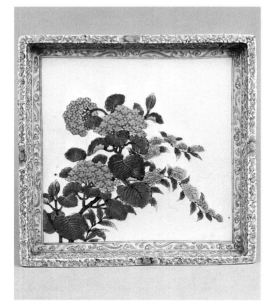

40

41

38. Sometsuke *vase; flower-and-bird and scroll design. H. 28.5 cm. Saga Prefectural Museum.*

39. *Large* sometsuke *bowl; rock and heron design. H. 16.7 cm, D. 42 cm. Tanakamaru Collection.*

40. *Square* sometsuke *dish; hydrangea design. Sides 22.7 cm. Tanakamaru Collection.*

41. Sometsuke *fan-shaped lidded container; peony scroll and phoenix design. 23.2 cm x 15.9 cm x 6 cm. Kakiemon Collection.*

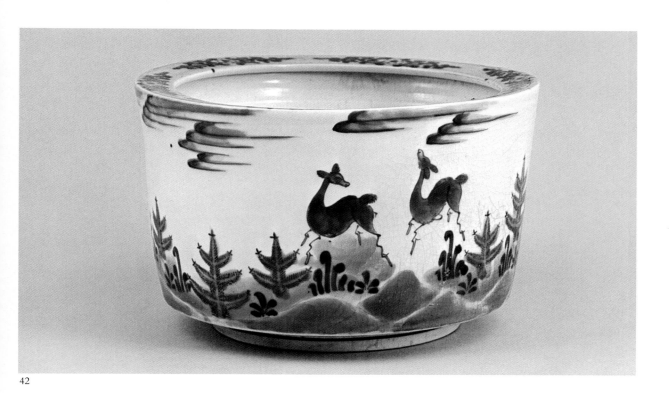

42

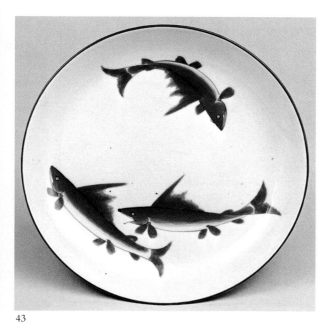

43

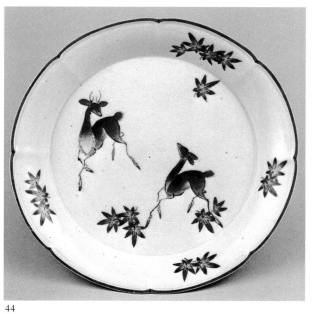

44

42. Sometsuke *incense burner; deer and tree design. H. 12.2 cm, D. 20 cm.*

43. Sometsuke *dish;* ayu *sweetfish design. D. 19.3 cm. Tanakamaru Collection.*

44. Sometsuke *dish; maple and deer design. D. 18 cm. Kamachi Collection.*

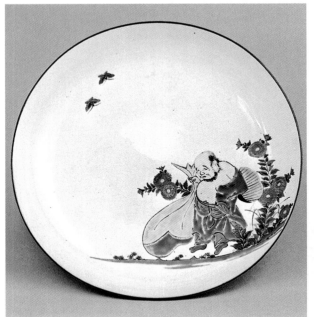

45

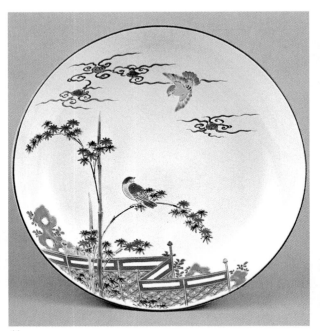

46

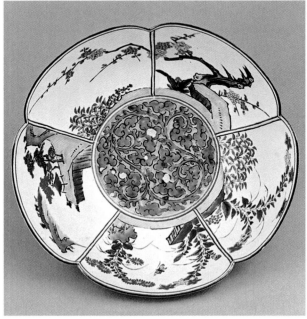

47

45. *Dish; Hotei and autumn flowers and grasses design. D. 24.8 cm. Tanakamaru Collection.*

46. *Dish; sparrow and bamboo design. D. 21.4 cm. Kamachi Collection.*

47. *Foliate bowl; flower and butterfly design. D. 25 cm. Saga Prefectural Museum.*

48. *Figurine of standing woman. H. 57.3 cm.*

49. *Figurine of standing woman. H. 35.5 cm.*

50. *Figurine of standing woman. H. 22.4 cm. Idemitsu Museum of Arts.*

51. *Octagonal mukōzuke dishes; grape and squirrel design. Left, 7.5 cm. Tanakamaru Collection.*

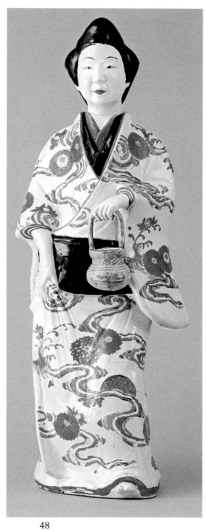

48

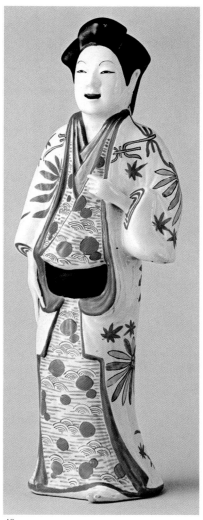

49

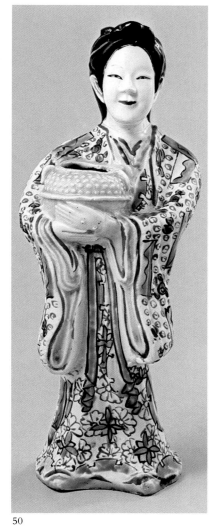

50

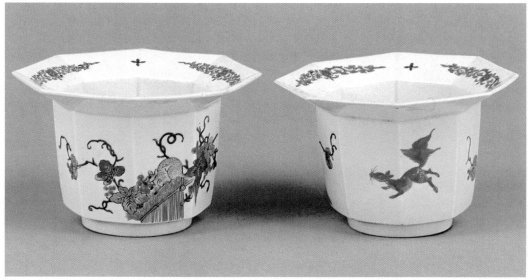

51

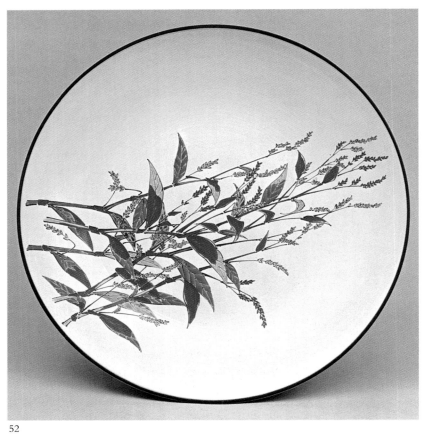

52

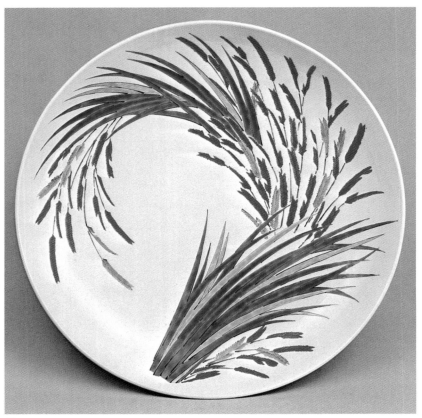

53

52. *Dish; flowering grasses design, by Kakiemon XIII. D. 45.6 cm.*

53. *Large dish; flowering grasses design, by Sakaida Masashi. D. 40.3 cm.*

IMARI

Compared with the pottery of other Japanese kilns, Ko Imari ware—literally "Old Imari", or Imari ware produced during the seventeenth and eighteenth centuries—is uniquely colorful, vigorous and varied. It was treasured by the Japanese of the Edo period (1615–1868), and was also popular overseas. The skills necessary for porcelain production came from abroad, and were subsequently developed by the potters in the province of Hizen in northern Kyūshū. The Imari tradition was quickly established, with the characteristic cobalt blue underglaze decorated porcelain known as *sometsuke*, and the polychrome enamel overglaze decorated porcelain known as *aka-e*, produced for both the domestic and export markets.

Porcelain was first produced in the Arita area of Hizen province at the very end of the Momoyama period (1573–1615). Production techniques developed rapidly during the early part of the Edo period and have continued to mature ever since. The name "Imari" is taken from the port from which the porcelain was shipped.

The Establishment of Hizen Porcelain

The Japanese are said to be extremely sensitive to the beauty of ceramics. Certainly, they were sufficiently fond of cobalt blue underglaze decorated porcelain to encourage its domestic production in the early decades of the Edo period, when the country rallied after years of civil war to enjoy the beginning of a peaceful era. Porcelain production was established in the region of Arita, on the western border of Hizen province, perhaps as a means to enhance the prosperity of the region.

There is some difficulty in ascertaining the exact origin of Imari ware. The generally accepted theory is that the Korean potter Ri Sanpei (Korean: Yi Sam-p'yong, 1579–1655), who was brought over to Japan in 1598, built the first porcelain kiln in 1616 at Tengudani kiln at Kami-shirakawa in the Arita region. Ri Sanpei eventually became a naturalized citizen of Japan, taking the name Kanagae Sanbei, and subsequent generations of his family worked for the Nabeshima clan in Hizen province.

Recently, however, a new theory has been proposed, suggesting that porcelain was fired from as early as 1605, setting back the start of Japan's porcelain industry by a decade. The possibility that another group of potters who settled in Japan at the same time as Ri Sanpei discovered the deposits of kaolin, the clay used to create porcelain, has arisen from a petition found in a document discovered in the Nabeshima fief archives known as the *Arita Sarayama daikan nikki* ("Record of the Office in Charge of Porcelain Kilns"). This document states that a group of potters led by a master craftsman called Ienaga Shōemon founded a porcelain-producing kiln at Tengudani in Shirakawa well before the hitherto accepted date of 1616. Shōemon was the grandson of Ienaga Hikosaburō, a master potter who had been granted a special license by Toyotomi Hideyoshi (1537–

Site of the original kiln at Tengudani.

1598), and it appears that Shōemon was in charge of a group of potters who fired "Nanking-style porcelain" at Tengudani. The document also states that Shōemon and his group were obliged to move elsewhere when a group of Korean potters from the nearby Taku area came to work at Tengudani, where Shōemon had built his kiln.

The *Arita Sarayama daikan nikki* is a semiofficial record kept by officials in charge of Arita Sarayama. According to a petition lodged by the descendants of Ienaga Shōemon, Ri Sanpei and other leading members of a group of Korean potters were in charge of the porcelain clay deposits at Izumiyama in Arita. Upon moving from the Taku area to Tengudani, they rebuilt the kiln established

Izumiyama kaolin quarry.

by Ienaga Shōemon and concentrated on the production of porcelain. This record raises doubts as to the accuracy of the hitherto accepted date of 1616 for the foundation of porcelain production in Japan.

The Korean potters built a series of kilns along the valley of Tengudani. They produced a wide range of wares, adapting them to suit the tastes of the time. They endeavored to improve both forms and designs, and their work developed from a Korean mid-Yi dynasty (1392–1910) style to a Chinese Ming dynasty (1368–1644) style of porcelain. Patterns and designs found on wares made during

A view of the town of Arita.

the Genna (1615–1624) and Kan'ei (1624–1644) eras are similar to those of Yi dynasty porcelain, but in the very short period from the mid-1630s to 1640s they changed entirely to a decorative Chinese porcelain style.

The Arita region where porcelain was made was under the jurisdiction of the Nabeshima fief, and for administrative purposes the area was divided into the Uchiyama ("Inner Mountain") and Sotoyama ("Outer Mountain") districts. These terms have now been adopted to distinguish the pottery made there. What is known as Arita Uchiyama porcelain was, for the most part, produced in kilns that specialized in porcelain production and that only fired stoneware in very small quantities for a limited period of time. The Sotoyama kilns, on the other hand, started by firing stoneware, and only gradually changed to porcelain production. Many of these kilns, though, were active only for a short time. The group of kilns at Kotōge, in the north of the Takeo district to the east of Arita, and the famous early Hyakkengama kilns, in eastern Arita, fired both stoneware and porcelain. The Arita Uchiyama kilns, however, specialized in porcelain, and produced many forms and types of wares, with celadon (*seiji*), cobalt blue (*sometsuke*), brownish black (*tenmoku*), and milky-white (*nyūhakude*) glazes. Particularly remarkable are the Chinese Ming dynasty techniques that were adopted from early on—sprayed cobalt (*fukisumite*), greenish white porcelain (*seihakujite*), and incised (*inkokute*) pieces. Compared with these Uchiyama wares, those first produced in Sotoyama are much simpler and less varied in design, and the cobalt blue used in the *sometuske* is somewhat less pure. The range of wares produced at Sotoyama was less varied; the clay used for throwing was rich in iron; and the colors were often

overfired or underfired. The craftsmanship, forms, and motifs used at Sotoyama nevertheless compare very favorably with those adopted by potters at Uchiyama.

Shoki Imari

The earliest cobalt blue *sometsuke* porcelain is nowadays referred to as Shoki Imari (the earliest Imari, until around 1643). There is a clear difference between Shoki Imari and Ko Imari wares, the latter having developed beyond the Korean Yi dynasty style, and started making use of Chinese techniques from the Ming and Ch'ing (1644–1912) dynasties, which involved mass-production methods. Shoki Imari may be further categorized as the period when techniques were being developed and wares were produced in considerable quantity.

From 1620 to 1628 potters seem to have experimented with refractory materials (*taikabutsu*) and redesigned their kilns, as there is evidence that kiln loading tools, stilts, and other materials were all tested. The potting and glazing of wares continued in much the same way as before, but the color of cobalt underglaze improved. The percentage of successful pots in each firing increased during this time, and a wide variety of pottery types was fired. Characteristic of the wares produced during these years are tall pots, such as bottles with high foot rings. Designs tended to be influenced by late Ming dynasty Chinese wares, rather than by the hitherto predominant Korean Yi dynasty style.

From approximately 1629 to 1643, pots were produced in quantity with little experimentation. This period is characterized by stability in firing techniques and a set style reflecting the influence of late Ming dynasty *sometsuke* porcelain. Consequently there was an increase in demand, which led to the Arita Sotoyama kilns ceasing production of stoneware and joining the Uchiyama kilns in the firing of porcelain, so that the whole of Arita now started mass producing porcelain. In 1637, the lord of the Nabeshima fief, Katsushige, ordered his senior administrator (*bugyō*), Taku Shigetoki, to protect the naturalized Korean craftsmen, improve the quality of porcelain, and preserve the secrecy of techniques. It was from this time that the Nabeshima fief was able to virtually monopolize porcelain production in Japan, since it spared no effort in watching over the potters working within its domains, and persisted in protectionist policies. Trade was initially conducted with China and Southeast Asia from the port of Hirado, in the nearby district of Matsuura, but by 1641 the port was changed to Nagasaki Dejima, where the

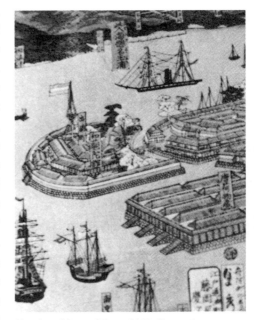

Foreign ships at Nagasaki Dejima; nineteenth century woodblock print.

Dutch East India Company (Vereenigde Oostindische Compagnie, or VOC) shipped to overseas markets. Local business was conducted by shipping wholesalers, who were based in the port of Imari and who shipped Hizen porcelain to various parts of Japan.

By this time, all sorts of everyday wares were being produced, so that although the original Yi dynasty-style pots, typical of the earliest porcelain production in Arita, lingered on to some extent, they were generally superseded by wares revealing a craftsmanship and design that owed more to Chinese than to Korean influence. Glazes ceased to be applied to unfired pots: rather, the technical improvement of painting cobalt decoration on bisque-fired pieces before applying the transparent glaze was adopted. During this period, the economic organization of each pottery workshop was organized into a feudal labor division system, whereby kiln owners employed specialist workers such as throwers, decorators, and modelers.

Ko Imari

Although Shoki Imari wares consisted almost entirely of cobalt decorated porcelain, Ko Imari included polychrome enameled wares as well as various forms of cobalt-and-enamel (*some-nishiki*) decorated pots with five-color (*gosai*) glazes and gold and silver painted on a cobalt underglaze decorated body. It was during the Ko Imari period that the potters developed the Ming dynasty decoration styles and pot forms into wares for which there was high demand, both inside and outside Japan.

Kilns firing Ko Imari porcelain extended beyond Arita Uchiyama and Sotoyama districts to cover the broad region of Ōsotoyama in the Saga fief. There is an international feel to these wares—not just in the vigor and variety of shapes, sizes, motifs, and designs, but in the nature of consumer demand for them and in the methods by which they were marketed.

Ko Imari—Early Period

The early period of Ko Imari is between 1644—when the art of porcelain making had been mastered and the kilns of Arita Sarayama were in regular production of Japan's first polychrome enameled porcelain, made under the protection of the Nabeshima fief—and 1660, when the Dutch East India Company first began trading in Imari ware. While these early Ko Imari pots retained certain Chinese Ming dynasty traits, they gradually acquired a more typically Japanese style, assimilating influences from the ink painting of the Muromachi period (1392–1573), the opulent screen and sliding-door paintings (*shōheki-ga*) of the

Kanō and Tosa schools of painting, contemporary popular illustrated books, and the gold lacquer ware (*maki-e*) of the time. The brushwork on the pottery displays what is now considered a characteristic Imari strength, while the pots themselves became much larger than the dishes, bottles, and bowls of the Shoki Imari wares, with big bowls (both molded and thrown) and square bottles being produced in quantity.

Ko Imari—Golden Age

Mainly as a result of the development of a more purely Japanese style of polychrome enameled porcelain, there was an increase in the commercial value of Ko Imari pottery during its early period. Consequently, potters were able to operate their kilns secure in the knowledge that their produce would sell. This commercial success of Ko Imari porcelain ushered in its Golden Age. Hizen porcelain now assumed a leading position in the world pottery market, previously monopolized by Chinese porcelain in the early part of the seventeenth century.

One reason underlying the growth in production can be attributed to the new era of peace and prosperity of Japanese society. From about 1661 to 1672, the Nabeshima fief was able to increase porcelain production, and a larger number of Dutch ships began to arrive at the port of Nagasaki Dejima. In 1672, eleven workshops of polychrome enamel decorating specialists were brought together by the fief authorities in Arita Uchiyama, enabling the Nabeshima fief to monopolize the production of extremely high-grade work, supporting the 150 pottery workshops in and around Arita Sarayama. In 1693, the second Nabeshima lord, Mitsushige, had a design copybook distributed in Sarayama; he also strengthened the fief's control over the pottery workshops and gave specific instructions on how standards should be improved. By the time the third lord, Tsunashige, took over, the Nabeshima fief controlled the economic management of the Arita porcelain industry, and extremely decorative Imari wares were being produced.

The real question, however, is how Ko Imari wares came to occupy such an important place in the world pottery markets. Here, the part played by the Dutch East India Company cannot be overstressed, although such prosperity is also the result of fortuitous circumstances. Imari porcelain appears to have been particularly fortunate in this respect, as Japanese porcelain was initially taken up by foreign traders because of the political and economic turmoil in China at the end of the Ming dynasty. These events disrupted the production of porcelain in China, making it impossible for Chinese potters to continue to satisfy world demand, and their monopoly of the porcelain trade in Southeast Asia and Europe during the sixteenth century thus came to an end. Hizen

Nagasaki Dejima, the only port open to overseas trade (limited to Holland and China) during the Edo period.

porcelain was at this time just reaching its peak and was capable of satisfying the European market in both quantity and quality. Members of the Dutch East India Company were quick to realize this and began shipping Ko Imari along their customary trade route from Japan to Europe.

The production of porcelain at Arita was further favored by domestic circumstances—in particular, by changes in living standards. During the Muromachi, Momoyama, and early Edo periods, eating and drinking utensils were predominantly lacquer ware. Porcelain was limited to items for use on special occasions by wealthy noble and military families. By the eighteenth century, however, the so-called popular culture had spread through the country from Edo (present-day Tokyo) and Kyoto. As the nation's prosperity and the power of the merchants and townspeople increased, so did the demand for porcelain.

Potters producing stoneware for everyday use had traditionally worked on a seasonal basis as farmers and had made pots when not engaged in farming. Imari porcelain workshops, however, came to be centered around a "kiln owner" (*kamamoto* or *kamanushi*), who employed specialist craftsmen to throw or form and decorate pots, and fire the kilns. Porcelain was now made predominantly to fill lucrative orders from foreign customers. In this period, porcelain was also considered high-quality merchandise and marketed in a cash economy both domestically and overseas, unlike stoneware pottery, which was generally traded in a barter exchange system.

Kilns at Arita.

Ko Imari—Late Period

Ko Imari wares reached their peak in the mid-1760s. By this time, demand was so great that porcelain wares were mass produced and used by all classes of society. Porcelain wares became part of daily life and were actually used rather than merely appreciated as decorative objects as they had been in the past. Perhaps as a result of this shift from decorative to functional, workers took less care in the production of wares, and from 1746 to around 1827 the overall quality of Imari porcelain began to decline.

During this time pottery dealers trading out of the port of Imari obtained permission from the lord of Saga (in whose fief the port was located) to market pots to the provinces through official clan channels. Mass production was increased still further, and porcelain was even shipped to Korea. The negative result of this, however, was that the eleven households that had specialized in polychrome enamel decoration were unable to keep up with the increased demand, and five new households had to be added to their number in 1770. At the same time, the number of officially licensed kiln operators increased from 150 to 220.

Naturally, the opening up of the market for porcelain affected the kinds of pots that were made. Unlike Chinese porcelain, Japanese porcelain was now being used and admired by the ordinary man in the street, and all sorts of functional objects such as oil lamps, *choku* cups, and saké drinking sets

appeared. It was from this time, too, that the opulent, decorative style known as *kinrande,* rich in gold and overglaze enamels, came to be used on lidded objects like jars and bowls. Today this ware might seem somewhat overly ornate. It should be realized, however, that *kinrande* was merely following the general trend in craftwork of the time, as can also be seen in the luxurious dyed and woven designs of late eighteenth century textiles.

Ko Imari wares finally began to decline, and a major fire at Arita Sarayama in 1828 was primarily responsible for the ensuing instability. Between 1830 and 1843, style, quality, and production all deteriorated rapidly. Imari ware was no longer considered to be an objet d'art, and many potters and decorators who had lost their homes and workshops as a result of the fire moved away to Sotoyama and Ōsotoyama. Things were so bad, in fact, that the Nabeshima lord Naomasa offered a loan of over three hundred *ryō* in gold and distributed excess rice from the clan's storehouses to help the Arita Sarayama workshops recover from the disaster. Naomasa's policies had the desired effect. Internal land and sea communications were greatly improved, and Arita Uchiyama's production began to recover. Porcelain became even more popular with the masses, and there was a sharp increase in the demand for everyday wares.

The craftsmanship and design of Ko Imari wares subsequently followed several new trends—anticipating, perhaps, the new era that was soon to dawn in Japan. The mood of society at this time is perhaps best reflected in the popularity of plates decorated with maps. As well as these "map" plates, large *sometsuke* plates were made in great numbers. One reason for their being so popular is that, despite the somewhat unsettled state of Japan at the beginning of the nineteenth century, popular culture itself was flourishing. Festive gatherings of city dwellers, farmers and fishermen were increasingly accompanied by saké and food served on large plates. Large platters, varying in size from fifty to eighty centimeters in diameter, were made in Arita Sarayama to meet this growing demand.

Imari Revival Period

Several incidents right at the end of the Edo period, starting with the arrival of the American "black ships" under the command of Commodore Matthew Perry (1794–1858) in 1853, forced the shogunate to allow American, French, British, and other foreign vessels to trade with Japan. In 1855, however, the Dutch East India Company stopped trading from Nagasaki Dejima. The foreign ships and their crews were frequently depicted on the *sometsuke* porcelain made during these years.

Trade with Southeast Asia and Britain was largely conducted through wholesalers. The wholesaling system in Japan was thriving, with a specialist Hizen wholesaler in Edo, and a Saga Fief Merchants' Association in Nagasaki. In Arita itself, porcelain merchants such as Tashiro Monzaemon of Honkōbira and Hisadome Yojibei of Nakanohara obtained permission from the Nabeshima fief authorities to trade directly with retail outlets within Japan, thus boosting the domestic market, and to deal directly overseas, thereby developing international trade. Indeed, the Nabeshima fief's monopoly of production and its protectionist policies in both the Uchiyama and Sotoyama districts were weakened around this time, and the system of officially registering polychrome enamel decorators now became little more than a formality. As a result, there emerged what are known as the "secret" enamel painters, who produced wares using enamel styles that were officially banned by the Nabeshima fief at the Yagenji kiln in Arita Sotoyama and other kilns in the neighborhood of the Toshiki valley near Izumiyama.

In 1867, a large polychrome enameled decorative jar with flower-and-bird design made in Arita Sarayama was displayed at the International Exposition in Paris. Important samurai of the Saga fief took this opportunity to join other samurai from Satsuma in southern Kyūshū in making a pioneering trip to Europe: not long afterwards, these same samurai were involved in the overthrow of the Tokugawa shogunate.

Ko Imari Kilns

A broad distinction can be made between Uchiyama, Sotoyama, and Ōsotoyama wares.

Uchiyama covers the eastern regions of modern Arita-machi and in the past included all the kilns situated within a radius of two kilometers from the Sarayama magistrate's office. This pine-covered mountainous area changed considerably after porcelain clay was discovered at Izumiyama and production started at Kami-shirakawa. Uchiyama kilns spread out from Kami-shirakawa to Kodaru, Izumiyama, Hiekoba, and the Sarukawa valley. There are also kiln sites at Iwayagawachi, Ōdaru, and Nangawarayama, but these are not usually included within the general classification of Uchiyama kilns. The Uchiyama area contains the kaolin deposits at Izumiyama, the *aka-e machi*, where the officially registered overglaze enamel painting specialists lived and worked, and the magistrate's office, and may justifiably be seen as the locus of Arita's porcelain production. It is also the religious center of the Yi dynasty Korean potters who came to Japan in the late sixteenth century: the Kanshō-ji temple (generally regarded as the potters' ancestral shrine) and the Hōgen-ji temple

(at which prayers were offered for the safety of the potters firing the kilns) are both to be found in the Uchiyama area. The Uchiyama kilns include the one run by the Tsuji family, who fired pots for use by the imperial household in Kyoto, as well as others that made high-class art porcelain and dinner service sets known as "presentation Imari" (*kenjōde Imari*). The potters from these kilns were given favorable treatment and were allowed to make use of the best quality clay available at the Izumiyama deposits.

The Sotoyama sector contains Ōhōyama and Hiroseyama at its center, and covers a broad area including the Kakenodani and Yamabeta districts. Porcelain fired at the Kakenodani and Hirose kilns during the formative period of Sotoyama wares was influenced by pieces made by many of the Uchiyama kilns, most of which were started during the second quarter of the seventeenth century (Kan'ei era). Kilns in the Ōhōyama area mainly produced goods such as domestic altar bottles, small bottles, and oil jars; those in Hiroseyama, on the other hand, fired small bowls and square *donburi* bowls. Pressed wares—bowls, square dishes, and plates—were among the everyday ware fired at the Sotoyama Kuromuta kilns. The Yagenji and Kōraijin kilns at Ōhō in Sotoyama, which are thought to have been built in the eighteenth century, fired oil jars, large and small bottles, and square dishes during the late Ko Imari period.

The Ōsotoyama sector included stoneware kilns that also fired porcelain, in the districts of Takeo, Hasuike, and Kashima. While they were given permission to use the clay from the Izumiyama clay deposits, they were only allowed to take rough-grained, low-grade material.

The Beauty of Ko Imari

Ko Imari consisted of cobalt underglaze decorated wares as well as polychrome and gold enamels over the cobalt underglaze. Such ware was not produced by a simple, family-style cottage industry system, but by a premodern system of industrial organization utilizing division of labor.

Ko Imari has a number of characteristics. Initially, wares were almost inevitably based on Chinese porcelain prototypes. They were fired to order for local shipping agents, financiers, and wholesalers, who ensured that the wares were marketable and in fashion, and the earlier Chinese style enameled porcelains were thus gradually replaced by wares more Japanese in style. In the Chinese style, the decoration of each pot is divided into five sections—one pattern being found in the center of the upper surface, another arranged around the center, a third around the rim, a fourth on the underside surface and the fifth on the foot ring. Most patterns found in the center of the pot's upper surface were Chinese in style, including landscapes; auspicious Chinese characters,

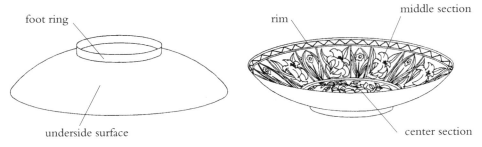

foot ring

underside surface

rim

middle section

center section

Five-section design.

such as those signifying "long life," "prosperity," and "happiness"; bird-and-flower designs; or designs including Chinese people. Patterns around these central motifs, together with those around the rim of the pot, were mainly repetitive floral motifs, which added to the feel of formality.

The huge increase in demand for bowls is evident from the fact that deep bowl shapes began to be mass produced, being mold-formed rather than thrown on the wheel. In the eighteenth century the Japanization of designs proceeded even further. They were clearly influenced by *ukiyo-e* woodblock prints and genre paintings, copybooks, and styles of the period. Even so, the results could not be called totally Japanese, for craftsmen still relied on an essentially Chinese style for decorating lids, rims, and shoulders of jars. Indeed, one could say that it was precisely because these Chinese traits were retained that porcelain pots sold so well. In addition, Chinese-style patterns and designs were drawn around Japanese pictorial motifs. The Ko Imari style should therefore be seen as a combination of various types of design. It may seem overly ornamental, but this decorative aspect was in accord with popular designs in contemporary gold and silver inlaid *maki-e* lacquer ware and dyed fabrics.

The Hizen Porcelain Trade

The establishment of porcelain production in the Hizen area, followed by the development of polychrome enamel techniques, brought the long period of stagnation in Kyūshū ceramics to an end. The prominence of porcelain produced in Hizen in national trade is clearly due to the local fief's economic policies. I would like here to consider various factors affecting the marketing of Hizen porcelain throughout Southeast Asia and in such far-off places as Europe during the latter half of the seventeenth century.

It should be realized that the Nabeshima fief chose to develop its local porcelain industry as a means of stimulating the economy of the fief under its

control. Clan leaders began to promote porcelain as a trade item of not just local, but also of national consumer interest, and expended considerable effort in levying production and transportation taxes. Moreover, from 1637, the Tokugawa government adopted an isolationist policy that forbade foreign trade. The porcelain industry in Hizen was, however, favored by its proximity to Nagasaki Dejima, where the central government established a special office for the purpose of keeping one trade window open to the world. The Nabeshima clan was thus able to deal with the Dutch and Chinese at Nagasaki Dejima after 1640. Trade was further improved by the development of domestic shipping lines. A number of wholesalers from various parts of Japan set up offices in the port of Imari, from which Hizen porcelain was shipped to local destinations.

The Dutch East India Company was largely responsible for the distribution of Hizen porcelain abroad. The company was active in Southeast Asia, with the full authority of the Dutch government for its financial dealings, and already had bases at Batavia in Java and Cape Town in South Africa before establishing trade with Japan. The expanding porcelain trade in Hizen was further helped by the fact that China experienced a period of turmoil from 1658 to 1682 during the transition between dynastic eras, and the political situation made it extremely difficult to obtain Chinese porcelain. Unable to meet the demand for porcelain from its European clients, The Dutch East India Company was forced to buy Japanese products. Lastly, during the seventeenth century demand in Europe shifted from gold and silver to glass and ceramics, as porcelain became a symbol of status and power for the royal families of countries like Holland, England, Germany, and France. These factors contributed to the development of Japanese porcelain, which was favored by the state of affairs both at home and abroad, and resulted in the export of Hizen wares to a number of countries.

Changes in the Porcelain Trade

The Dutch East India Company provided the link between porcelain made by unknown craftsmen in provincial Hizen and an international porcelain market in Southeast Asia and Europe. The company was originally founded as a government-backed trading company in 1602, and became an extremely profitable business, backed by a fleet of 150 trading vessels, 40 cargo ships, and a force of 10,000 men.

The Dutch trading post in Japan was first established at Hirado, before being moved at the Tokugawa shogunate's command to Nagasaki Dejima. For the next two and a half centuries friendly relations were maintained between Holland and Japan. According to extant records kept by the trading post, the

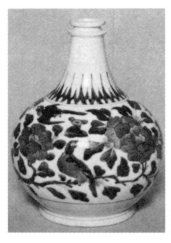

Medicine jar: such pots were exported to Southeast Asia by the Dutch East India Company.

first dealings in Japanese porcelain occurred in 1653, when 2,200 medicine pots were exported to meet an order by a pharmaceutical merchant in Batavia. These records, now in the Hague National Library, show that regular trade of fine quality Hizen porcelain started in 1660, and that the largest quantities of Japanese porcelain were shipped overseas between 1663 and 1672. According to these records, the company's export trade ceased in 1757, although individual members of the trading post continued to trade small quantities as a sideline business.

The boom in the porcelain trade occurred from 1663 to 1664. Most of the exported wares were cobalt blue decorated medicine pots, plates, cups, lidded butter dishes, and incense burners, although some large lidded polychrome enameled jars used for burning incense were also traded.

From the 1670s and 1680s, Hizen porcelain evidently began to be widely used in European homes, as such everyday items as cups, oil jars, oil bottles, water bottles, and shallow bowls were exported by the Dutch East India Company. From 1688 to 1703, a number of large, decorative enameled bowls and jars and other lidded pots were exported, along with oil and saké containers, lugged and rectangular bottles, and small jars. A fairly large number of Kakiemon style wares were also traded. From about 1713, there was a considerable increase in orders for polychrome enameled wares.

By around 1697, the Arita Sarayama council system was functioning, and the senior town councilor, Takagi Hikoemon, was appointed by the Nabeshima authorities as the officer in charge of porcelain exports to China and Holland from Nagasaki Dejima. The same year at least four Dutch ships put into Dejima, loading up with cargoes of bowls, *choku* cups, jars, flower vases, and handled bottles.

Trade began to decline from about 1735, and despite a brief improvement in the 1750s, it never fully recovered. One reason for this was the revival of the porcelain industry in China and the ability of the Dutch to purchase Chinese porcelain directly from Canton in South China. Also around this time, European porcelain factories began to meet the demand for Oriental-style porcelain.

A Summary

The earliest cobalt underglaze decorated Arita wares reflect the prevalent styles of the Momoyama period. All the early works—*sometsuke* saké cups with autumn leaf motifs; bowls with floral scroll patterns; plates and dishes with grape and vine designs—were made by Korean craftsmen brought to Japan. Their struggles in their new country, immersed in the intricacies of clay and fire, are expressed in the deep cobalt blue decorations of dishes and in the melancholy of the pine and plum motifs on narrow-necked bottles.

Conditions improved at the start of the Edo period in the early seventeenth century. Ships sailing under the flag of the Dutch East India Company began putting into Nagasaki Dejima, and Imari wares started to rival Chinese porcelain exported along the "Ceramic Route," from Southeast Asia across the Indian Ocean to Cape Town in South Africa, and from there to Amsterdam. Large overglaze enameled jars and plates began to decorate the palaces of Europe—Versailles, Hampton Court, and Shönbrunn. Thanks to the Dutch East India Company, Imari wares were not confined to private houses, but were also used at the lavish receptions held in the baroque and rococo castles and courts of Europe. The popularity of Imari ware finally led to the establishment of porce-

Imari pots formed part of the interior design of Vienna's Schönbrunn Palace.

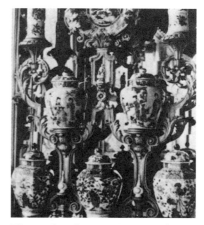

The opulent baroque interior of Charlottenburg Palace in Berlin also displays Imari ware.

lain kilns in Europe, which largely imitated the porcelain made in Japan, so that the Imari style ultimately strengthened cultural ties between East and West.

In the late Edo period (late eighteenth to mid-nineteenth centuries), domestic demand for Imari porcelain increased considerably. Ships transporting rice to and from wholesalers located all over Japan would put into the port of Imari and load up with porcelain wares, which were then distributed not only to the courtiers and military upper classes, but also to the merchants and ordinary people of Edo, Kyoto, and Naniwa (present-day Osaka). Thus, everyone came to know about Imari porcelain, although the "presentation" wares were prized solely by members of the nobility, the shogun's household, and various clan lords.

In the late Edo period Imari wares came to be used in inns, farmhouse kitchens, and shops all over the country, mainly due to the perfection of the land and sea distribution system at this time. There was hardly a single house in the country that did not own an Imari oil lamp—either a cobalt blue underglazed piece with plum, pine, or bamboo grass motif, or a polychrome enameled piece with a floral design. Characteristic of late Edo Imari was the *choku* noodle cup, which was an essential item on every dining table. These two popular items, with the natural beauty typical of Imari ware, were designed in a variety of forms and styles, instilling a deep appreciation for both function and beauty in the Edo citizen's heart. Ko Imari wares thus combine various formal aspects of Edo period taste with the spread of popular culture, and even today continue to be an essential part of the unique world of Japanese porcelain.

KAKIEMON

The early history of Japanese arts and crafts is characterized by the direct influence of styles from the Korean Silla (c.305–935) and Koryo (935–1392) dynasties and the indirect absorption of Chinese styles during the Nara (710–794) and Heian (794–1185) periods. During the Muromachi period (1392–1573) craft wares directly reflected Chinese styles of the Sung dynasty (960–1280) and the indirect influenc of Korean styles of the early Yi dynasty (1392–1910). In the Momoyama period (1573–1615), Japanese crafts were given impetus by middle Yi and also European styles. In the early Edo period (1615–1868), Japanese arts and crafts were directly influenced by and received inspiration from Chinese Ming (1368–1644) and early Ch'ing (1644–1912) dynasties before developing a uniquely Japanese style, which, in turn, reflected the social conditions of the time. The Edo period style in the arts and crafts, which mutually influenced one another, was both lyrical and lucid, and was clearly part of the vigorous culture of the time.

Ceramic production was extremely limited before about 1600, but saw an explosive growth in the Edo period. A radical development of techniques and improvement in quality was complemented by a booming export trade and active domestic market. Crafts flourished during the Edo period due the development of a commercial system, the activities of naturalized foreign craftsmen, the use of new materials and techniques, and the spread of family industries.

Ceramic production, in particular, was stimulated by groups of potters brought to Japan from Korea following Toyotomi Hideyoshi's military invasions of the Korean peninsula in 1592 and 1597. These Korean potters were responsible for the founding and expansion of kilns, for cooperation between kilns, and for establishing pottery as a domestic industry rather than as a subsidiary occupation of agriculture, as it had hitherto been. These potters also established porcelain production, which had not existed in Japan before this time. Deposits of kaolin were discovered, and the production of porcelain wares developed rapidly under the patronage and protection of daimyo.

Following the discovery of porcelain clay in Japan, late Ming dynasty porcelain enameling techniques were introduced directly to Japan from China in 1643. Enameled porcelain was central to Japanese ceramic art during the Edo

period. In view of the social conditions prevailing at the time, it is remarkable that these two epoch-making technical innovations (the discovery of kaolin clay and the use of overglaze enamel decoration) both took place in the remote district of Arita in northwestern Kyūshū. While Seto had been the center of Japanese pottery production until Edo times, Arita took over a substantial part of this role in the Edo period. Porcelain production and the perfection of enamel overglazing led to the development of a thriving industry.

The Japanese terminology for overglaze enameled pottery and porcelain is perhaps confusing—the terms *aka-e* (literally, "red painting"), *iro-e* ("color painting"), and *uwa-e* ("overpainting") are all used to refer to this type of ware, although usage may vary slightly according to by different scholars and craftsmen.

The history of Japanese enameled porcelain—from the first successful firing through various stages of progress until finally it was marketed both at home and abroad—must be considered within the context of Japan's cultural history. As mentioned above, Japanese arts and crafts once reflected Chinese influences, which arrived via the Korean peninsula and had therefore undergone some modification. With Japanese *aka-e,* however, it is important to note that forms, designs, and decorative and firing techniques were all imported directly from China. It is necessary to study the historical process by which the earlier, fixed China-Korea-Japan route was replaced by a direct link to China.

Japanese *aka-e* is classifiable roughly into Hizen (Arita), Kaga (Kutani), and Kyō (Kyoto) styles. Both Hizen and Kutani wares have a porcelain body, while Kyō *aka-e* enamel is on a relatively low-fired stoneware body. Porcelain was a late introduction into Kyoto ceramics.

The Hizen kilns, being close to Nagasaki, were geographically well-located to allow the direct influence of Chinese enameled porcelain techniques. Furthermore, the nearby ports of Imari, Hirado, and Dejima provided convenient bases for overseas and domestic trade. The kilns of Arita manufactured high quality wares on a semi-mass production basis and thrived throughout the Edo period under the patronage of the Nabeshima fief.

The enameled porcelain of Kutani is unusual in that, while kilns were located in the Daishōji temple compound, they were supported by the wealth of the neighboring Kaga fief (present-day Ishikawa prefecture) and were indirectly influenced by the urban culture of Kyoto. There are various theories about the origin of Kutani ware. I personally believe that this ware originated during the Meireki era (1655–1658). The kilns then went out of production during the Genroku era (1688–1704) and were revived during the Bunka era (1804–1818), in the late Edo period. Wares from the first kilns are now called Ko Kutani ("Old Kutani"), while those from subsequent periods of production are known simply as Kutani.

Kyoto enamel decorated wares use pottery rather than porcelain, so the ground color of the pots is usually a soft eggshell white or cream, rather than the porcelain white. Based upon a long tradition of the aristocratic taste of the imperial court, Kyoto wares boast a comfortable and graceful charm. Despite its somewhat low market value, Kyoto *aka-e* is extremely artistic.

Edo period Hizen porcelain is highly marketable and at the same time is characterized by a noble beauty comparable to the work of such Kyoto master potters as Nonomura Ninsei (mid-seventeenth century), Ogata Kenzan (1663–1743), Okuda Eisen (1753–1811), and Aoki Mokubei (1767–1833). In an odd parallel with the three major types of Japanese enamel decorated ceramics, Hizen porcelain had three styles that formed mutually influencing traditions: Imari, Kakiemon and Nabeshima.

The Perfection of Early Aka-e.

There is as yet no conclusive theory about the development of early Japanese enameled porcelain. The traditional belief that Kakiemon I was the first to succeed in making enameled porcelain in Japan under the guidance of a Chinese potter in the late Kan'ei (1624–1644) or early Shōhō (1644–1648) era was recently challenged, although with no reliable evidence.

I shall first summarize the accepted "Kakiemon theory" with regard to the establishment of Japanese *aka-e* before presenting my ideas about certain problems concerning Kakiemon success in this field. In particular, I will discuss the kiln at Nangawara-yama in Arita.

In *Kakiemon,* edited by the Kakiemon Research Committee (1957), and *Ko Imari,* edited by the Ko Imari Research Committee (1959), I published nearly all the passages from old documents that had the slightest connection with the creation of Hizen porcelain and the establishment of *aka-e* by Kakiemon. At the time I merely introduced them as research materials. These extracts have been discussed from various viewpoints, and I believe I fulfilled my responsibility as the matter stood at the time. In some respects, I owe an apology to the Sakaida Kakiemon family, but I do not regret having published the family's records, which I had been studying for twenty years. My publication of extracts from the *Sarayama daikan nikki* ("Record of the Office in Charge of Porcelain Kilns") in the Nabeshima archives and of all the records kept by the Sakaida family throughout the Edo period effectively formed the basis of my

The seal used by Kakiemon I. The character *fuku* ("happiness") is inside two squares.

study of the lineage and beauty of Kakiemon wares. I wish to emphasize here that these records are invaluable to the study of the Kakiemon tradition.

The belief ascribing the origin of Japanese *aka-e* to Sakaida Kakiemon I has been transmitted over the centuries. As seen from the vantage of the present, the following facts form the basis of this belief (viz. *Kakiemon XIII* [in Japanese], Kodansha Ltd., 1974).

1) A man who helped behind the scenes in the creation of *aka-e* porcelain was Higashijima Tokuzaemon, a pottery dealer in Imari, who was a good friend of Yamamoto Jin'emon, a retainer of the Nabeshima fief and the official clan supervisor of ceramic production at Arita Sarayama at the time (1648). He purchased overglaze enamel materials from a Chinese merchant at Nagasaki and supplied them to Sakaida Kizaemon, with whom he had business relations, in the hope that Sakaida could produce enameled porcelain in Hizen.

2) Sakaida Kizaemon—or Kakiemon I, who is believed to have played a leading part in the creation of *aka-e*—was a *kama-nushi* (kiln owner) of some artistic taste, though not himself a potter, painter, or craftsman. A close friend of the ceramic dealer Tokuzaemon, he was much attracted to Ming dynasty Chinese *aka-e* and is thought to have collaborated with Tokuzaemon in the establishment of *aka-e* techniques in Arita.

3) The Sakaida family at Nangawara-yama in Arita was descended from a high-ranking samurai of neighboring Chikugo province. This time-honored family moved from Chikugo to Hizen province during the Tenshō era (1573–1592).

4) The "Kakiemon" workshop appears to have been managed jointly by the Sakaida family and its relatives and was not Kizaemon's own individual enterprise. It seems that Kizaemon and his father, Ensei, acted as representatives of the family as a whole and were responsible for running the workshop in their capacity as *kama-nushi*. As was customary at the time, the names of craftsmen and other employees were never recorded alongside those of the *kama-nushi*; only kiln owners' names were mentioned.

5) Some scholars claim that *aka-e* porcelain wares from the Kakiemon kiln were not made earlier than the mid-Edo period. However, a letter addressed to Sakaida Kakiemon, dated November 8, 1685, signed by the Hizen Saga clan official Ōishi Gunpei—and thus may be regarded as a semiofficial document—contains the following passage: "There is no doubt that *aka-e nishikide* (polychrome enameled porcelain) has been originated by you. You are therefore permitted to continue your trade forever in this field. You should be grateful to our lord." This statement confirms that the Kakiemon kiln produced *aka-e* enameled wares, and reveals how it received its status. The letter is dated ten years after the Saga clan's official workshop had moved, in 1675, from Nangawara-yama to Ōkawachi-yama.

6) The *Kōgi on-yakimonokata oboe* ("Memorandum from the Official in Charge of Ceramics") inventories "one *hon-gama* (glaze-firing kiln); one *kara-usu* (clay-pounding) shed; one *odōgu-ya* (storehouse for kiln equipment); two *kara-usu* (clay pounders); two large carts; one *aka-e gama* (enamel-firing kiln); five bales of rice; two hundred *momme* of silver. . . ." and is signed by the clan officials Kakuzaemon and Yamada Zengoemon, and addressed to "Sakaida Kakiemon" (note the use of the Kakiemon name). This document gives an idea of the situation of the Kakiemon kilns around 1680.

The Lineage of the Kakiemon Family

The Sakaida family appears to have moved to the Nangawara-yama area in Arita around 1615, after the summer siege of Osaka Castle. Earlier the family had been engaged in the manufacture of *kawarake* (unglazed earthenware) at Shiraishi village (now Ariake town), by the Ariake Sea. It seems they continued to make stoneware after moving to the Nangawara-yama area (possibly in the area of the Tenjin-mori kiln) and began to make porcelain in around 1623 or 1624. Sakaida Ensei was the head of the family at the time and seems to have been friendly with Gensō Tojaku, the eminent Buddhist priest at the Shōten-ji temple in Hakata (present-day Fukuoka).

The main building of the Kakiemon house dates from the Edo Period (1615–1868).

It was perhaps during the time of Ensei's son, Sakaida Kizaemon, that the family became the *kama-nushi* of a fully equipped ceramic workshop. Some details of the early Kakiemon period, represented by Kakiemons I, II, and III, can be gleaned from inscriptions on the family's tombstones in the lower graveyard at Shimo-nangawara, and the upper graveyard on the hill near Kami-nangawara. Certain scholars have tried disprove the pedigree of early Kakiemons by adding irrelevant epitaphs and posthumous Buddhist names to the necrological listing, instead of taking the trouble to visit the graves and find out the truth. Such interpretations are, however, both groundless and farfetched.

The middle Kakiemon period (mid-Edo period, around the Genroku era) was an eventful period of transition and interchange between the pure Imari and Kakiemon styles. During this time, the development of Arita Sarayama was actively encouraged by the second and third Nabeshima fief lords, Mitsushige and Tsunashige, who ruled the fief during the Empō (1673–1681), Teikyō (1684–1688), and Genroku (1688–1704) eras.

Evidence from the *Sarayama daikan nikki,* together with the inscriptions on pottery molds and records belonging to the Sakaida family, shows that in the late Kakiemon period (1844–1868), Shibuemon, Sanaemon, Wasuke, and other kinsmen of the Kakiemon family worked together under the village headman and *kama-nushi,* Kakiemon. They developed a semi-mass production system in order to meet domestic demand.

Pure Imari and Kakiemon Styles

During the Edo period, the porcelain wares fired at Arita Sarayama kilns in Hizen province were collectively called Imari ware. The term Imari is mentioned in the *Kakumei-ki* (the diary of Priest Hōrin Shōshō, written between 1635–1669) and other literary sources, as well as in the *Sankai meisen zu-e* ("Illustrated Catalogue of Famous Land and Marine Products"). In Europe, Hizen ware was classified as Japanese porcelain as opposed to Chinese porcelain. A record of the Dutch East India Company includes a word thought to be read as Fizen (Hizen). It is hard to accurately classify the white, celadon, cobalt underglaze decorated, and enameled porcelains made in Arita, but they are tentatively classifiable into pure Imari and Kakiemon styles. The other main style of the area was Nabeshima, which refers to the wares produced at the official kiln run by the Nabeshima fief. The decade between about 1605 and 1619 is called the period of porcelain nascency and stabilization, and is characterized by Korean Yi dynasty forms and styles. By around 1640, however, porcelain techniques were perfected and stylistically resembled late Ming dynasty Chinese *sometsuke. Aka-e* techniques are generally believed to have

been perfected around 1643. Early Arita *aka-e* went through a stage of imitating Chinese blue-and-white and enameled porcelain, more in a late Ming than a pure Imari style. Consequently, the Imari workshops in Arita Uchiyama and the Kakiemon Nangawara-yama workshop initially copied the colors and designs of Chinese porcelain, producing wares that were similar in design.

The distinction between pure Imari and Kakiemon styles around 1672 was still unclear. At this time, craftsmen specializing in painting enamel decoration were brought together in Arita Sarayama. All Imari craftsmen imitated the Chinese Ming *fuyode* form of decoration (a large central medallion surrounded by panels enclosing decorative motifs) as well as Ming motifs such as flowers in baskets, flowering grasses, and flowers-and-birds. Some experts prefer not to make a classification into pure Imari and Kakiemon styles; yet two distinct styles with separate forms, designs, and colors did emerge after 1670 due to the need to adapt to market demand. A relatively clear difference between Imari and Kakiemon styles can thus be seen from the late seventeenth century, when the overseas export market became brisk. The characteristics of the pure Imari style are generally understood to be as follows:

1) The same type of clay was used for jars, bowls, and dishes regardless of whether they were to be decorated with *sometsuke* (underglaze cobalt) or polychrome enamels.

2) A wide range of wares were produced, the quality of which differed according to the purpose for which it was made, such as *kenjō* wares for presentation to the imperial court, wares for export, and wares for everyday use.

3) Extremely complex designs in which the surface of the pot is usually divided into sections, each decorated with combinations of pictorial and geometric stylized motifs together with background patterns.

4) Fine and elaborate decoration on the interior surface of dishes and bowls, with very brief, sketchy depictions on the exterior surface.

5) Combinations of different motifs, which tend to be flat, stylized, and compact, in styles such as *hana-zume* ("packed flowers") or *nuri-tsubushi* ("all-over painting"), which almost conceal the white porcelain body. Colors and color combinations also tend to be extravagant. A highly decorative style, lacking the aesthetic sense required for works of art, was also characteristic of the pure Imari style.

In contrast to the pure Imari style, which started out with complex, excessive motifs and coloring after the Chinese Wanli mode, the Kakiemon style is characterized as follows:

1) Careful attention was paid to all stages of manufacture, from refining clay type for both *sometsuke* and *iro-e*, to glazing and firing. The *Tsuchi-awasechō* ("Notebook on the Preparation of Clay Bodies," dated 1690) owned by the

Sakaida family, shows that the clays were prepared according to whether they were to be decorated with *sometsuke, some-nishiki* (or *nishiki-e*, cobalt underglaze combined with enamel decoration), or *nigoshide* (milk-white body). The *Tsuchi chōgō nikae* ("Memoranda of Clay Recipes") of the Sakaida family contains details of clay recipes such as *ondōgu tsuchi* (for wares made by special order of the fief government), *ondōgu shiroyaki tsuchi* (for the milk-white wares used in the fief government and the lord's castle), as well as clays for *jōmono* (high-quality pieces), and ordinary quality *sometsuke*. Private notebooks give a still more detailed listing of clay recipes for celadon wares, large bowls, *ōmono* ("large pieces," referring to jars), *fuchi-beni* (red iron pigment used for coloring the mouth rim), and other items. Most scholars of Kakiemon style appear to concentrate on the subject and color effect of the decoration. However, family documents reveal that the Kakiemon craftsmen carefully studied all stages of manufacture, and we should not overlook the fact that the Kakiemon style is also reflected in the preliminary processes of clay preparation and shaping.

2) After circular bowls, square bowls, and dishes had been bisque fired, they almost always had the mouth rim painted in *fuchi-beni* before glaze-firing; the *fuchi-beni* was rarely used on Imari wares, however. The Kakiemon workshop used it as a precaution against chipping, to which the rim was vulnerable, and served also to enhance the composition of the enamel decoration. *Fuchi-beni* generally thought to be a form of overglazing, but this is not so: it was applied at the same time as the glaze, following bisque firing. This technique thus provides a clue as to whether a piece is genuine or false.

3) Shaping methods included wheel-throwing for *maru-mono* ("round shapes," like dishes and bowls) and *fukuro-mono* ("bag-shapes," such as jars and vases), and molding, in which a piece roughly fashioned on the wheel was finished off in a mold while still soft. Dishes approximately twenty centimeters in diameter were made with shallow, slightly curving shapes to prevent them from warping. Deep bowls were formed in press molds (*kata-uchi*). Bowls and dishes with relief decorations (such as a stream, a standing tree, or *takara-zukushi* —"lucky symbols") were also made by press molding. The milk-white *mukōzuke* bowls with a grape and squirrel design (see Plate 51) are excellent examples of *mentori* (faceted forms) with clear, sharp angles.

4) Shards unearthed from old kiln sites show that milk-white pieces were not only fired at Kakiemon kilns but also at Arita Uchiyama kilns. The latter, however, are mostly from small bowls and dishes, while fragments of Kakiemon style wares are often from larger-sized pieces such as jars around twenty-seven centimeters in height, bowls and dishes measuring thirty centimeters in diameter, as well as covered vessels with relief decorations. A similar trend is noted in *densei* (extant pieces handed down, rather than excavated).

5) Subjects and compositions recalling Far Eastern and, in particular, Japanese-style painting are dominant in the decoration of both *sometsuke* and *iro-e* works. Often similar motifs to those on *maki-e* lacquer and textile wares were used, perhaps taken from the artists' and craftsmen's copybooks published throughout the Edo period.

6) Naturalistic designs representing spring and autumn, especially, show the obvious influence of the Kanō, Tosa, and Shijō painting schools, while the Rinpa school also had an effect on styles. This illustrates how potters tried to establish an essentially Japanese style of porcelain decoration.

7) One noteworthy characteristic of Kakiemon style porcelain decoration is the splendid balance between the decorated and undecorated areas, the composition being conceived as a work of art on a porcelain clay body. The style characteristically aims at elegant understatement by avoiding excessive decoration and leaving much of the milk-white porcelain empty of decoration. Compositions sometimes recall early Edo folding screens, small fan paintings, or *maki-e* lacquer designs of the Muromachi period, all showing compositional characteristics of Japanese-style painting.

8) A common feature of Kakiemon style decoration on both *sometsuke* and *iro-e* wares is the strength and fluency of brushwork, as can be seen in, for example, the jar shown in Plate 23. One can see the idyllic and lyrical Japanese taste in the dynamic depiction of birds and the flowing strokes of the brush used to paint the leaf veins, flower petals, and flower hearts on this jar, as well as in the detailed observation of the birds, particularly their feathers on the dish in Plate 46 and the tile in Plate 35.

9) Unlike pure Imari style wares, the artistic quality of the decoration on the "back" side of each piece matches that of the design on the "front." Although such motifs as tendril scrolls or peony scrolls can be somewhat monotonous in terms of composition, they are executed in elegant flowing brushstrokes.

10) Study of *densei* (handed down, rather than excavated) pieces of the Kakiemon style suggests that the Kakiemon kiln was a quasi-official kiln that followed the practices of the official workshop of the Nabeshima fief in employing potters and painters (decorators) of distinguished ability. It seems that especially for decoration, artisans accomplished in Japanese-style painting were employed.

11) The Kakiemon style features combinations of colors rather than single colors. The composition is particularly accentuated by one or two colors, with the key shades being, say, red and blue, or blue and green. While the pure Imari style is characterized by bright, deep, loud colors, the Kakiemon style tends to favor subtler hues. The pigments were also prepared by the painters

Notes for *aka-e* pigments and design from the *Aka-e enogu awase oboe*.

themselves. The *Aka-e enogu awase oboe* ("Memoranda on Recipes of *Aka-e* Pigments") records recipes for both deep and light enamel shades and even mentions special enamels used for certain parts of a composition.

In general, one can say that the beauty of the Kakiemon style is due to its artistic quality and noble grace. Wares from the official Nabeshima fief kilns, meanwhile, had a dignified, sonorous beauty, which suited the taste of daimyo but tended to be overly devoted to technical precision, with elaborate decoration in a somewhat stiff style of brushwork. While the Kakiemon and Imari styles used many enamel colors, Nabeshima wares mainly used the three colors red, green, and yellow. The fact that three different styles—Imari, Kakiemon, and Nabeshima—existed within the same realm of Hizen enameled porcelain meant that the range of taste and demand of the times could be satisfied.

Neverthless, it should be stressed that due to the increase in foreign trade in and after the mid-Edo period, both the Kakiemon and pure Imari styles (the latter including some Chinese stylistic traits) began to incorporate certain elements from each other in order to increase their sales potential, often making it difficult to clearly distinguish between the two styles.

Classification of Kakiemon Style Wares

Densei pieces that have been categorized broadly as being in the Kakiemon style, were probably fired in the following kilns.

1) Mainstream Kakiemon wares—porcelain wares fired at kilns under the direct management of the Sakaida *kama-nushi,* Kakiemon, with the help of other members of the Sakaida family.

2) Collateral Kakiemon wares—pots fired at the porcelain kilns at Kami (upper) and Shimo (lower) Nangawara-yama (such as the Higuchi, Genzaemon, and Mukurodani kilns) or at *yoriai-gama* (cooperative kilns) with common subject matter and design composition. These "collateral" Kakiemon wares consist mostly of cobalt underglaze decorated porcelains (*sometsuke*).

3) Next to be noted are the exclusively *sometsuke* wares fired in the kilns of the Matsugatane-gama group and known as the official wares of the Ogi clan. These were made when members of the Sakaida family were working at the kilns.

When attempting classification, it should be remembered that many Kakiemon style *sometsuke* pieces are likely to be from the Higuchi and Mukurodani kilns at Nangawara-yama. Compared with mainstream Kakiemon wares, however, the clay body of these pots is coarser. The cobalt pigment used on them contains impurities and fires a darker, duller blue than the pure cobalt, and the decoration is comparatively rough and crude.

The Beauty of the Kakiemon Style

There are no distinctive designs on wares generally classified as Kakiemon style from the period when enameled overglazing was being established. One can, however, see a general trend towards smaller vessels with designs of flowering grasses or peonies and bowls with cloud-and-dragon, phoenix, or chrysanthemum motifs drawn with abbreviated brush strokes in a style apparently inspired by Chinese cobalt underglaze and enamel decorated wares. There may also have been some influence from Chinese Wanli (1573–1620) and Tianji (1621–1627) enamel decoration styles. It is now believed that a characteristically Japanese style began to appear once the porcelain body had become more or less established and the techniques of enamel painting and firing perfected.

Kakiemon style designs may be roughly classified into three types: realistic images, relatively stylized forms, and abstract patterns, In addition to copying Ming *sometsuke* and *iro-e* porcelain, another notable feature is the recurrence of subjects, themes, motifs, and compositions borrowed from Japanese painting (much of which is ultimately of Chinese inspiration). There are also designs emulating textile patterns of the East, including those of India and Java. Some motifs were partly influenced by European designs.

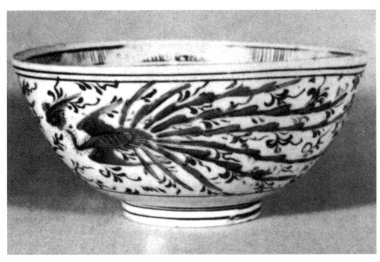

An early Kakiemon *aka-e* bowl.

1) Works influenced by Chinese polychrome enamel-decorated designs of the late Ming and early Ch'ing periods display two or more separate panels, or units, separated by background patterns. The main decorative panels contain Chinese-style pictures of flower-and-bird, landscape, figure, plant, or similar motifs.

2) Designs influenced by Japanese-style painting of the Edo period include flowering plants or flower-and-bird subjects with themes of spring and autumn, usually painted on dishes and bowls. These show various degrees of influence of the early Edo period painting of the Kanō and Tosa schools (cf. Plates 11, 12, 15, 19, 22, 23, 46, 47)

3) Products of the Kakiemon kilns, as well as the official Nabeshima kilns, include many that were made as *odōgu* (objects for use by daimyo) by order of the fief government or other feudal lords. The *Gochūmon egata* ("Designs Supplied to Order") file in the Sakaida family records lists the names of buyers, ordered items, quantities, schedule of deliveries, prices, and specimen designs giving examples of forms and decoration.

4) Many designs were taken from the woodblock printed picture copybooks published in Naniwa (Osaka) and Edo (Tokyo) during the Edo period. *Densei* wares show that pictures in these books were frequently borrowed for *sometsuke* and *iro-e* designs.

5) The undersides of Kakiemon vessels are commonly decorated with simple tendril scrolls or peony scrolls, mostly in cobalt underglaze blue only. The *shippō* (interlocking circle) design illustrated in the Sakaida family's *Gochūmon egata* file was the basic type of underside design on Nabeshima official wares

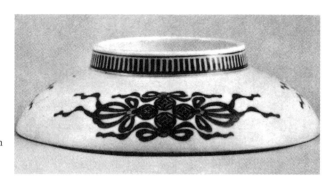

The underside of a bowl with a *shippō* design, and a comb pattern on the foot ring.

and can also be found on Kakiemon wares. A foot ring decorated with a conventional comb pattern which was discovered among porcelain shards excavated from an old Kakiemon kiln site at Nangawara-yama will also help with the classification of Kakiemon designs.

6) In response to the European taste for chinoiserie, Hizen porcelain began to be exported in quantity by the Dutch East India Company in the seventeenth century. Symmetrical designs of flowering plant motifs appeared on Kakiemon wares. These were often called Dutch designs, although it appears that such flowering plant designs were borrowed from patterns of Indian printed textiles. Very few porcelain wares made for export were decorated with European figure subjects; rather, such designs were made in response to domestic, not overseas, demand.

7) One particularly noteworthy stylistic trait in Kakiemon ware is the unique construction of composite designs. In contrast to the complicated, incongruous compositions of the pure Imari style, Kakiemon design compositions are not merely a number of independent elements haphazardly thrown together but consist of harmonious combinations of a few single units. The resulting composition forms a coherent and well-controlled whole, unlike that of the pure Imari style.

This can be seen in, for example, the quail and flowering grasses, bamboo and tiger, and other such composite designs typical of the Kakiemon style. The main motif is placed either to the right or left of center and the subordinate motif diagonally across from it to give the total design balance. Alternatively, a flower-and-bird design is painted as the main motif on the "front" side of a jar, and a design of flowering autumn plants in light touches on the "back" side plays a subordinate role. Typical composite designs include:

Flowering plant motifs: rock and plum tree; rock and chrysanthemum; rock and autumn grasses; brushwood fence and ivy.

Flower-and-bird motifs: plum tree and spring birds; peony and phoenix; chrysanthemum and wild bird.

Traditional groupings: *shō-chiku-bai* (pine, bamboo, and plum, the three "lucky" plants); peony and *shishi* lion (the "queen" of flowers and "king" of beasts); bamboo and tiger; quail and flowering grasses; maple and deer; waves and plovers; *karako* (Chinese children) and autumn grasses; Chinese figure and flowering grasses; flowering grasses and butterflies.

Designs combining these motifs are painted in deftly balanced compositions on the surfaces of jars, bowls, dishes, square bowls, and vessels of various shapes. The distinguished talents of the decorators created first-class "porcelain paintings" rather than mere ornamental designs.

Influences on Kakiemon Designs

I am not the only person who, when appreciating both mainstream and collateral Kakiemon style works in art museums and collections at home and abroad, has noticed the difference to the pure Imari aesthetic. The Kakiemon style is influenced to some extent by the academy painting styles of the Far East, notably those of the Sung dynasty in China and such purely Japanese styles as the classical *yamato-e.*

Quail designs, which have become one of the fixed types of decoration in the Kakiemon style, find their ultimate source in masterpieces on this subject by Li An-chung (fl. 1119–1131), who belonged to the Sung Imperial Painting Academy. In Japan, quails were frequently depicted by the artist Tosa Mitsuoki (1617–1691) on folding screens. This style and subject matter is also reproduced in the section on "September Subjects for Poem-Pictures of the Twelve Months: Quails and Rushes" of the *Ehon tsūhō shi* copybook. The *Oshi-e tekagami* copybook, published in 1636 in Naniwa, also contains a sketch entitled "Autumn Quails." The Kakiemon mainstream and collateral kilns at Nangawara no doubt borrowed motifs and compositions from these sources in response to the taste of the time. Maple and deer designs, like those in Plates 42 and 44, are also familiar Japanese motifs. The decorative design of deer and autumn plants on the inside cover of a lacquer writing box from the Muromachi period was probably inspired by an autumn poem from the *Kokinshū* (c. 905) poetry anthology: "In a rustic place, how forlorn the autumn when the cry of deer awaken us." In Volume 3 of the *Ehon tsūhō shi* copybook can be found a picture of the "Eight Sights in the Southern Capital (Nara): Deer in the Field of Kasuga," which is another fixed design of the Kakiemon style. Shards with maple and deer designs in *sometsuke* are still occasionally

discovered in the old kiln sites on the hill behind the present Kakiemon kilns. The designs are richly lyrical and reminiscent of the old poem: "The autumn wind must be chill on Mount Kasuga; deer cry sadly in the fields at its foot."

One consistent influence on the Kakiemon style is the colorful *yamato-e* genre of painting. In the Kakiemon polychrome porcelain decoration there is a richly lyrical naturalism that expresses the very essence of Japanese sensibility. The lingering resonance of the understated, amply spaced designs, preserving as much of the pure white porcelain surface as possible, together with the fresh color combinations, constitute a uniquely Japanese realm. The tradition of the Kakiemon style arose from and is an expression of the mind and aesthetic sense of the Japanese.

PLATE NOTES

IMARI

1., 2. Cobalt underglaze decorated bottles; pine tree and plum blossom designs. Plate 1, H. 22 cm. Plate 2, H. 21.7 cm. Arita Ceramics Museum.

These two precious examples of Arita ware date from the very beginning of porcelain production in Japan. The bottles were unearthed in the lowest stratum of the Tengudani kiln site at Kami-shirakawa in Arita Uchiyama. Remarkably, research shows them to have been fired at least as early as 1605. The glaze is bluish white and has not been fired to full temperature, while the underglaze cobalt is slightly dull, indicating they were made before techniques had developed.

3. Cobalt underglaze decorated dish; grapevine and butterfly design. D. 18.8 cm. Saga Prefectural Museum.

This dish is reminiscent of Korean mid-Yi dynasty cobalt decorated porcelain. The moodiness of the indigo touches and the sense of nostalgia in the weeping trails of the vines and butterfly are superb. The *dami* style of cobalt underglazing is typical of early Arita ware. The porcelain clay body is slightly bluish. The flat dish is stable and is thought to have been fired at the old Hiekoba kiln in Arita Uchiyama. It was possibly made by Korean potters living and working in Japan, far from their home country.

4. Cobalt underglaze decorated plate; bird and chrysanthemum scroll design. D. 21.3 cm.

Here we have a dynamically painted sparrow, while the edge of the plate has been decorated with a flowing chrysanthemum scroll. The contrast of light and dark in the cobalt pigment is magnificent, while the glaze itself is tinted slightly blue and has crazed. A number of fragments, similar in both style and design, have been unearthed at the Hyakkengama kiln. This would indicate that in all probability this plate was fired at the same kiln, which flourished during the early period of Imari ware production.

5. Cobalt underglaze decorated foliate bowl; floral scroll design. D. 33.5 cm. Idemitsu Museum of Arts.

Large bowls are rare among early Imari wares. This one, with a foliate rim, is unwarped and has been modeled with great feeling. There are slight traces of blue in the glaze. There is a beautiful flow in the lines of the floral scroll, and the brushwork is superlative. This piece is apparently from the Hyakkengama kiln.

6. Cobalt underglaze decorated dish; rabbit design in spray glaze (fukisumite). *D. 19.3 cm. Imaemon Antique Ceramics Center.*

The design of a rabbit leaping across a dark, moonlit night is a traditional congratulatory

motif in the East. The design has been achieved in the spray method of glazing, which appears on everyday wares made in China during the Ming dynasty. The dish is flat with a very narrow rim. It was fired in the old kiln of Hiekoba in Arita Uchiyama, where a large number of shards of this type of work have been unearthed.

7. Azure-glazed dish; white heron design. 17 cm x 12.2 cm. Kamachi Collection.

This piece has been passed down through the centuries, and its history can be gauged by comparing the dish with similar looking shards unearthed at the old kiln site of Ōdaru in Arita Uchiyama. It is an unusual, irregularly shaped dish, press molded and decorated with marbled cobalt effects.

8. Celadon bottle; incised floral design. H. 20.2 cm. Arita Ceramics Museum.

This bottle is typical of the earliest period of porcelain production in Japan, and the celadon glaze is reminiscent of the celadon pots made in Korea's Koryō dynasty. This long-necked (*tsurukubi*) bottle was unearthed in the lowest stratum of the kiln site at Tengudani. The chrysanthemum design was incised with a bamboo carving tool.

9. Cobalt underglaze decorated fluted bottle; floral design in panels. H. 31.5 cm. MOA Museum of Art.

This piece is believed to be from the Hyakkengama kiln, one of a group of kilns in the north of Takeo. It was probably fired around the end of the Genna era (c. 1620), which was when early Imari wares were gradually shifting from simple Korean style designs to the slightly more complex Chinese-style cobalt underglaze decorated porcelain. Shards resembling the lip and body of this bottle have been earthed from the old kiln site, while the slightly bluish tinge of the porcelain body is typical of Shoki Imari ware.

10. Cobalt underglaze decorated foliate dish; flower, bird, and Chinese literati design. D. 38 cm. Kamachi Collection.

The style of decoration known as *fuyōde* was used by Ming dynasty Chinese potters, and was adopted around the early to mid-Edo period by Japanese potters before being adapted to suit local taste. The central part of this dish has a design of water, mountains, and Chinese figures, while the foliate edge has been divided into ten sections, each somewhat ornately decorated with flower-and-bird, Chinese figure, or tree designs. There is great freshness in the marvelous suggestiveness of the indigo cobalt.

11. Polychrome enameled flat dish; bird-and-flower design. D. 31.1 cm. Kurita Art Museum.

The *fuyōde* decoration style was the first of various types of Chinese Ming dynasty styles to be adopted in Hizen porcelain production. Almost all the early Imari export wares were *fuyōde* style patterns. This is a particularly fine example of the overglaze enameled wares of the Jōō and Kanbun eras (1652–1673), when Japanese porcelain production attained maturity and stability.

12. Cobalt underglaze decorated bottle; bird-and-flower design in six panels. H. 27.5 cm. Idemitsu Museum of Arts.

This piece appears to have been fired at or near the Ōdaru kiln of Arita Uchiyama around the end of the Kan'ei era (c. 1640), when cobalt underglaze decorated Arita pots were shifting in style from Korean Yi dynasty to Chinese Ming dynasty style. Bird-and-flower motifs are painted in the panels.

13. Azure-glazed square bottle; rock, peony, and shishi *lion relief design. H. 20.3 cm.*

Shards similar to this bottle have been unearthed at the site of the Hiekoba kiln in Arita

Uchiyama, indicating that press-molded bottles were produced there. There is considerable ingenuity and artistry in the blue porcelain relief of the peony and lion motif. This bottle is probably one of a pair made during the early Edo period and used as a saké bottle by travelers.

14. *Large overglaze enameled vase; design in three panels of popular customs. H. 38.5 cm. Tanakamaru Collection.*

This vase has been divided into three "window" panels by means of a blackened silver chrysanthemum scroll design. In each of these "windows," an early Edo period dancing girl has been painted in reddish black with occasional dashes of red adding variety to the design. This full-bodied vase is unfinished and is probably an experimental piece, although a smaller one similar to the example shown here may be found in the Amsterdam Museum of Art.

15. *Large two-toned overglaze enameled vase; bird-and-flower design. H. 60.5 cm. Kamachi Collection.*

This large vase has just red and gold overglaze enamels, an extremely rare use of color tones on enameled vases of this kind. There is considerable vitality in the composition, featuring a floral design of asters and pinks together with the occasional wild bird on the body of the vase, while the shoulder and lid have been given rather more ornamental flower-and-bird designs.

SHAVING DISHES (PLATES 16 TO 18)
Shaving dishes are among the more typical examples of unusually shaped wares found during the peak period of Ko Imari production (around the time of the Genroku era). String was passed through the two holes at the top of the dish, and the cutaway section was placed under the customer's chin before shaving. However, these dishes seem to have been more decorative than functional, for many have been decorated with designs of *ukiyo-e* woodblock print-type women, together with typical Oriental bird-and-flower motifs. Dishes like these were even apparently used as hanging signs by barbers in Europe.

16. *Polychrome enameled shaving dish; genre design. D. 28.1 cm. Saga Prefectural Museum.*

This design is in the popular genre; the center shows a cart on which a basket full of spring and autumn flowers has been placed. One end of the harness rope is held by a woman in kimono. The charming border has been painted with autumn leaves and deer.

17. *Polychrome enameled shaving dish; genre design. D. 27.6 cm. Kurita Art Museum.*

This is a typical example of Ko Imari export ware. A Nagasaki courtesan looks down from a raised reception room in the Maruyama entertainment district; her face is rather large, thereby giving her a somewhat coquettish appearance. Overall, the dish combines good decorative techniques with elaborate brushwork.

18. *Polychrome enameled shaving dish; genre design. D. 30.6 cm. Tanakamaru Collection.*

The design here is given a sense of perspective by the way in which the girl appears to be moving away behind the screen. The brushwork is not elaborate, but rather charmingly simple, while there is a dynamic vitality in the enamels of the chrysanthemum and butterfly design around the edge of the dish.

19. *Polychrome enameled vessel; chrysanthemum, peony, and genre design. H. 27 cm. Kanbara Collection, Arita Historical Museum.*

From the mid-Edo period, during the Genroku, Kyōhō, and Hōreki eras (late seventeenth through mid-eighteenth centuries), export Imari wares began to be decorated in a Japanese, rather than simply imitation Chinese, style. The vessel pictured here was made at this time as one of a pair and is thought to have been used as a plant pot. The design of peonies and chrysanthemums alternating with female figures is masterfully achieved.

20. *Cobalt underglaze decorated jug; floral design. H. 23 cm. Kamachi Collection.*

This jug has been given an Oriental look, with the main floral motif around the body of the pot, bordered at top and bottom by cobalt underglaze decoration of extremely pure color. It seems likely that this type of decoration was considered by Europeans to be Oriental.

21. *Polychrome enameled jug; bamboo, grass, and flower design. H. 24 cm. Kamachi Collection.*

The jug seen here is typical of wares used at the dinner tables of European families at the end of the seventeenth century. The design around the lip and the base of the pot gives the jug a European feel, while the main design of bamboo, peonies, and chrysanthemums has been painted in minute detail.

22. *Polychrome enameled ewer; landscape design. H. 20.8 cm. Imaemon Antique Ceramics Center.*

This bottle is known as *kendi* in Japanese and appears to be a variation on a form found in Southeast Asia. This type of ware, in both cobalt underglaze and enameled porcelain, was made in large quantities for export and is fairly rare in Japan. The porcelain body, enamel techniques, and luster of the glaze all suggest that this ewer was made about 1660, when export production was flourishing.

23. *Polychrome enameled ewer; floral design. H. 21 cm. Kurita Art Museum.*

This ewer has had its sides fluted in the *shinogide* style, and the glaze has a slight bluish tinge. The design features both spring and autumn flowers—plum, narcissus, peony, and chrysanthemum.

24. *Polychrome enameled lidded container with handles; chrysanthemum design. H. 17.5 cm. Arita Ceramics Museum.*

This pot is typical of Imari export ware and was probably used for sugar. The body of the pot has been "fenced" with vertical stripes forming a background for bright chrysanthemum sprays. The two handles are purely decorative. The original lid to the pot is missing; the one shown here was made in England.

25. *Polychrome enameled lidded bowl and saucer; flower and bird design. H. 21 cm; saucer, D. 33.3 cm. Kanbara Collection, Arita Historical Museum.*

This pot was probably made as a soup tureen. Both lid and saucer are undamaged, and it is particularly valuable as an example of Imari ware that has returned to Japan from Europe. A complex scroll design in cobalt underglaze forms a background to three double linked lozenges with floral and phoenix designs in overglaze enamels.

26., 27. *Large polychrome enameled jar; Dazaifu design. H. 59.7 cm. Genemon Pottery Center.*

At one time there was a demand, both at home and abroad, for large incense jars in the Ko Imari style. These were made in pairs with the same shape and design and were used as decorative pieces. This pair is painted with a design characteristic of western Japan, with its realistic portrayal of the town of Dazaifu in Tsukushi (present-day Fukuoka).

Plate 26 shows the main hall of the Kanzeon Temple; Plate 27 the Tenmangū (Anrakuji), which was built to honor the Dazaifu administrative authorities.

28. *Polychrome enameled lidded jar;* nanban *("Southern Barbarian") design. H. 24 cm. Kobe Municipal Museum of Nanban Art.*

Very few Ko Imari pieces have such an exotic design as this jar. The design of a man astride an elephant on one side and a dancing girl on the other, seems to pulse to the beat of music from South Asia. The overall appearance of the design is enhanced by the black background.

29. *Polychrome enameled faceted jar; genre design. H. 35 cm.*

This jar features a restful design of three women strolling through a somewhat Chinese-looking scene, reminiscent of paintings found in Edo period picture books. Here the scene is made more realistic by the inclusion of a dog and some chickens, which add charm to the lavish design. The octagonal shape gives the pot a dynamic feel, and the lip is skillfully made.

30. *Large polychrome enameled dish; courtesan and "Eight Views of Ōmi" design. D. 41.5 cm. Kanbara Collection, Arita Historical Museum.*

This is an extremely decorative large dish with all the lavish charm of a Genroku era (1688–1704) picture book. At the center, in slightly three-dimensional perspective, is a landscape made up of scenes from the "Eight Views of Ōmi," in which a courtesan walks across a bridge with wooden railings. The border features a particularly rich floral honeycomb design in which the red and gold enamels serenely harmonize.

31. *Large polychrome enameled flat dish; basket of flowers and bird design. H. 54.8 cm. Kanbara Collection, Arita Historical Museum.*

Oriental flower basket designs were used in order to satisfy the European taste for chinoiserie, a taste that is fully reflected in the symmetrical design of this dish, with a basket of peonies on a table in the center, and chrysanthemums and pinks to the right and left respectively. The border of the dish features rocks, peonies, and chrysanthemums, together with two phoenixes. The dish itself is perfectly formed.

32. *Polychrome enameled dish; ribbon* (noshi) *and arrow design. 30.5 x 19.4 cm. Tanakamaru Collection.*

During the years of peace of the Edo period, great care and attention was paid to seasonal festivals such as the peach blossoms of spring and the iris blooms of early summer. Ko Imari polychrome enameled celebratory dishes like the one here were made from about the eighteenth century (mid-Edo period). The iris festival was in honor of boys, and this kind of bow and arrow motif was designed to accompany the sets of warrior dolls on display. The *noshi* streamer motif is exquisite.

33. *Large polychrome enameled lidded jar; flower-and-bird design. H. 47 cm. Kurita Art Museum.*

This lidded jar is more decorative than functional, and its full-bodied form is majestic. The body and lid of the jar feature "windows" containing rich chrysanthemum and peony designs. The cobalt underglaze, polychrome enamels and overall glazing are magnificent, while the lid is superbly sculpted.

34. *Large polychrome enameled vase; peony,* shishi *lion, and sacred bird design. H. 82 cm. Kanbara Collection, Arita Historical Museum.*

The design on this large polychrome enameled piece shows how exotic Oriental taste

could, in fact, harmonize with baroque architecture and rococo interior design. The pigment of the underglaze is a rather heavy black, but on the other hand, it forms a striking contrast with the enamel colors.

35. *Polychrome enameled lampstands; flower basket design. Left, H. 59 cm. Kanbara Collection, Arita Historical Museum.*

These are splendid European copies of export Imari ware. It is impossible to tell whether they were originally made as lampstands, but they may well have been, for the shoulder of the pots above the beveled body seems perfectly suited to take the lamp apparatus. The "window"-style designs of rock, peonies, and a flower basket are in perfect harmony with the rectangular bodies of the stands.

36. *Polychrome enameled bowl; "five ships" design. D. 36.4 cm. MOA Museum of Art.*

The *nanban* style paintings—among which the Imari wares featuring *kōmōjin*, or Europeans, are usually classified—are generally extremely decorative. A design like this was not made for export, but was applied to luxury wares destined for the residences of samurai lords or wealthy merchants in Japan. The bowl has three Western-style ships on the inner surface and two on the outer surface, hence the name of the design.

37. *Cobalt underglaze decorated bowl; foxtail millet and quail design. D. 20.8 cm.*

This foxtail millet and quail motif was common on Hizen porcelain wares throughout the Edo period, but a number of stylistic changes occurred over the years. This particular bowl, made for everyday use, was fired at Arita Sotoyama kilns in the late Edo period. Produced at a time when Hizen porcelain was finally coming into everyday use, the popular design is lighthearted and humorous.

38. *Cobalt underglaze decorated plate; pine tree and crane design. D. 22.3 cm.*

The plate pictured here has been vivaciously painted with a popular, felicitous design of pine tree and crane, which almost resembles a dark blue curtain. The whole plate is imbued with a lively functional beauty, and was probably mass produced at the Arita Sotoyama kilns in the late Edo period.

39. *Polychrome enameled oil jars. Back left, H. 5 cm, D. 9.1 cm. Front left, H. 6.2 cm, D. 9.6 cm.*

By the 1850s and 1860s, in the late Edo period, all sorts of wares were being produced as public demand for porcelain increased. Oil jars like these were placed by women's vanity mirrors, and feature a variety of extremely attractive designs.

40. *Polychrome enameled figurine. H. 46.5 cm.*

This is one of the better examples of Ko Imari figurines and was probably modeled after an original Hakata or Kyoto doll design. The collar of the girl's kimono is in a style typical of Ko Imari wares, while the hem has been been painted a deep red. Gold has been added to accentuate the collar. The girl's smiling expression is particularly charming.

41. *Pair of polychrome enameled figurines. Left, H. 18 cm. Kanbara Collection, Arita Historical Museum.*

The liveliness of these folk figurines, which were probably inspired by a village festival or saké party, is striking. The figures have been decorated just with overglaze enamel, in red, gold, green, blue, and black. The floral patterns on the clothes are simple, yet beautiful.

42. *Large cobalt underglaze decorated plate; map of East Asia. D. 52.1 cm. Saga Prefectural Museum.*

In the late Edo period, scenes from picture books were painted on large Arita underglaze decorated plates. Maps both of Japan and of the world—usually with Japan at the center—perhaps reflect the growing interest in foreign cultures. What is particularly interesting about this plate is that it records distances in *ri* (2.44 miles) between Japan and foreign countries. A fairly large number of such map plates were produced during the Tenpo era (1830–1844), in the valley kiln of Ōhōyama in Arita Sotoyama.

KAKIEMON

1. *Jar; landscape design. H. 26 cm. Mid-Edo period. Idemitsu Museum of Arts.*

Hizen polychrome enameled jars are generally decorated with natural scenes divided into four, six, and occasionally eight equally distributed sections (known as *warimon*). This jar, however, has been designed with a continuous composition extending horizontally, rather like those found on *fusuma* sliding doors. It is painted on a warm milk-white porcelain body in deep-toned colors, with light, fluent touches. The colors are particularly clear as a result of good firing. I have seen a similarly decorated jar in the Leeuwarden Museum in the Netherlands. The Chinese-style landscape design with a moored boat recalled a similar Ko Kutani bowl. However, Kakiemon wares feature fine drawing, realistic representation, and bright hues of blue, red, and other colors, whereas Ko Kutani designs are characterized by darker colors, less painterly designs, and lack of subtle depiction. Both have their respective interesting points, but the Kakiemon style tends to reveal a more vivid color scheme.

2. *Dish; bamboo, plum, and bird design. D. 24.8 cm. Early Edo period.*

A dish identical in design and form to the one photographed here may be found in the gallery of Asiatic art in the Rijksmuseum, Amsterdam. A few other dishes were brought back to Japan recently, two of which I was able to positively identify as examples of Kakiemon work. They have a splendid milk-white porcelain body with flower-and-bird designs in the Kakiemon style. Spring and autumn birds are dynamically depicted, with empty space nicely balancing the design composition. The dish shown here features particularly bright color tones.

3. *Dish; boating design. D. 23.1 cm. Early to mid-Edo period. Tanakamaru Collection.*

Kakiemon designs featuring human figures are mostly Chinese in style, and similar to those illustrated in the *Ehon tsūhō shi,* a pictorial copybook published in the mid-Edo period. A few years ago, I studied a dish with an almost identical design in the Porcelain Gallery of the National Museum of Dresden. The dish was in excellent condition, and its milk-white body and polychrome decoration were magnificent. The design on this dish features an idyllic landscape reminiscent of a springtime lakeside scene in China. The design is well composed within the circle of the dish's rim and pleasantly evokes the graceful atmosphere of boating. The red and deep blue tones are especially vivid.

4. *Jar; flower and butterfly design in three panels. H. 22.2 cm. Early Edo period. Saga Prefectural Museum.*

This polychrome enameled jar is an important example of wares produced during the

period in which the Chinese cobalt and enamel decorated style of the Ming dynasty was being adapted to Japanese taste. A jar with similar coloring can be found in the Oriental Antiquities Hall of the British Museum, London, which also features deep blue, green, and brownish yellow as the basic colors with a slight touch of red for the hearts of the flowers. The decoration is reminiscent of folding screen paintings of the early Edo period and would seem to be inspired by the Sōtatsu style of decorative painting transposed into a three-paneled ceramic design. The neck, with deep blue washed over a series of concentric circles, is somewhat similar in style to that found on Ko Kutani wares.

5. *Jar; flowering grasses design in four panels. H. 25.5 cm. Kakiemon Collection.*

This cylindrical jar is divided into four painted columns. These constitute panels framed with double rectangles drawn freehand, which enclose, alternately, wild roses with small blossoms and peonies in full bloom. The decoration is simple and matches the vertical shape of the jar, but the flowers are created with forceful brushstrokes. The painting reveals the hand of a skilled decorator, but the porcelain body contains tiny particles of iron in the glaze layer. The angular shoulder is painted with floral scrolls in a *hanazume* ("packed flower") style.

6. *Dish; shishi lion and peony design. D. 27.3 cm. Early Edo period. Kamachi Collection.*

Classification of early examples of Hizen polychrome enameled wares in Japanese and foreign collections is needed in order to cast light on the color effects of wares made around 1650, at the time when Japanese enameled porcelain was perfected. This dish, with a *shishi* lion and peony design in the Chinese style, is valuable for the study of early Hizen as well as early Kakiemon. It is probably reasonable to suppose, therefore, that this dish is from the early Edo period, in an early Kakiemon style typified by fine iron particles remaining in the porcelain clay body and somewhat rough brushwork in the overglaze enamel decoration. The style is reminiscent of Ko Kutani ware, yet the color tones of the deep blue *shishi* lion and the brownish yellow peony flower are Kakiemon in style.

7. *Three-legged candlestick; wisteria design. H. 33 cm. Mid-Edo period. Tanakamaru Collection.*

The Sakaida Kakiemon family has kept records of all orders received from the office of the Nabeshima daimyo as well as from pottery dealers in Naniwa (Osaka) and Kyoto. These documents date from the mid- to late Edo period and include detailed records of what pieces were ordered for what purpose. This candlestick was discovered in the grave of Kuroda Tsunamasa, the fourteenth-generation lord of the Hakata fief (present-day Fukuoka prefecture), in 1947 when the Kuroda family tombs were moved due to construction work. Resting on three legs surmounted by lion masks, and decorated with a wisteria design associated with the Kuroda family crest, this candlestick was certainly part of the household furnishings of the feudal lord's family. It reveals subtle, careful and minutely detailed workmanship. The glaze is partly crazed due to the candelstick having been buried for some time. Interestingly, a similarly shaped splendid pair of candlesticks, with stems decorated in bamboo and plum designs, are in the Victoria and Albert Museum in London, although they have metal, rather than porcelain cups in which to place the candles.

8. *Decagonal bowl; bamboo and tiger design. D. 23 cm. Mid-Edo period. Tanakamaru Collection.*

During the late seventeenth to mid-eighteenth centuries, the Kakiemon workshop joined others in the Nangawara-yama region to fire their porcelain together. With increasing demand both at home and abroad, potters began to make identical molded wares, which were then glazed and fired in the cooperative kiln before being decorated with different designs by each workshop. This practice resulted in the production of bowls of hexagonal

and other faceted forms, which, unlike their Imari equivalents, have clear, regular forms with sharp ridges. The lip of each pot was usually decorated with a floral design and the rim painted with iron oxide, while the inside of the pot was painted with a single flowering spray, usually peonies. The outside was generally decorated in overglaze enamel designs with such varied motifs as bamboo and tiger; Chinese figures; landscapes; pine, bamboo, and plum (the three "lucky" plants); or flower-and-bird patterns. These were painted with ample space left around them to display the beautiful milk-white color of the porcelain body.

9. Octagonal bowl; peach and floral scroll design. D. 21.3 cm. Mid-Edo period. Tanakamaru Collection.

The faceted bowls illustrated in Plates 8 and 9 were both press molded, a characteristic of the Kakiemon style. The bowl in Plate 9 is tall and, though angular in form, its inner surface consists of softly curving faces. The eight sides are decorated alternately with realistic peach sprays and flower-and-vine scrolls. The deep red background of the scroll panels contrasts with the whiteness of the porcelain body.

10. Jar; flower-and-bird design. H. 16 cm. Mid-Edo period.

This jar is one of many pieces of porcelain exported to Europe in the early eighteenth century and recently brought back to Japan in considerable numbers. The design is somewhat Imari-like, but the lyricism of the Kakiemon style can be seen in the stylistically drawn flowers and birds. The glaze is faintly tinged with blue. This small jar is one of several that is difficult to classify distinctly as either pure Imari or pure Kakiemon in style. The difference between the two styles, as well as the influence they had on each other, is evident in this jar's graceful form, the clarity of its color scheme, and the typically Japanese mood of its design. It is perhaps unsurprising that common features occurred naturally as Arita Sarayama was situated in a narrow valley. The Imari-style Kakiemon ware was probably produced around the Hōei-Kyōhō eras (1704–1735) in response to market demand.

11. Dish; pine-bamboo-plum and bird design. D. 21.8 cm. Kakiemon Collection.

To satisfy the European market, Kakiemon porcelain was decorated with broadly asymmetric, continuous designs, instead of more typically Japanese motifs in which right and left were equally balanced. This kind of design, with pine, bamboo, plum, and rock fanning out from the bottom of the dish, was a typical Kakiemon decoration designed to suit European taste.

12. Dish; plum and quail design. D. 13.2 cm. Saga Prefectural Museum.

Whereas quail are combined with millet in Plate 15 as an autumn design, this combination of plum and quail is a springtime design and reflects the cultural influence of Japan's trade with Europe. Small, flowering autumn grasses were added later in the space to the left, and—to Japanese eyes, at least—this detracts from the original balanced composition and gives the dish a certain asymmetrical feel.

13. Small deep bowl; poppy design. D. 9.8 cm.

This piece could either be a bowl or a cup. A large poppy design has been painted in a stylized manner adapted to European taste, divided into two separate compositions on the "front" and "back." The colors are even clearer and brighter than those of the preceding piece. The heart of the flower and the buds on the right and left show a novel style of decoration. Bright red accentuates the flower, while the blue and green reveal the deft firing skill of the potter.

14. *Ewer; peony design. H. 15.3 cm.*

This ewer has European-style peonies around the sides together with extremely stylized peony sprays on the right and left shoulders of the pot. Compared with earlier Kakiemon wares, the enamel colors are deeper and reflect a modification of design that was motivated by trade with the Netherlands.

15. *Octagonal bowl; millet and quail design with border band of halved floral roundels. D. 22.3 cm. Idemitsu Museum of Arts.*

Kakiemon porcelain designs include the autumnal theme of quails, examples of which may be found in both domestic and foreign collections. Indeed, quail designs were so widely disseminated that they began to be imitated at potteries in Germany, France, and England around the end of the eighteenth century. Pieces with millet and quail, flowering autumn grasses, and other such motifs were exported by Dutch trading vessels to meet the demand in Europe for Far Eastern porcelain.

16., 17. *Gourd-shaped ewer; grape and squirrel design. H. 16.3 cm.*

Kendi type pitchers, which used to be made in Southeast Asia and Europe as everyday ware, were also manufactured in Japan in pure Imari and Kakiemon styles. They were primarily for export, made in molds, in mostly gourd or ewer shapes, with Imari or Kakiemon style designs in overglaze enamels.

Plates 16 and 17 show both sides of a Japanese-style ewer, decorated with a grapevine and squirrel design, and painted in bright overglaze enamel colors. The grape and squirrel motif was one of the typical designs of the Kakiemon style. The one on this ewer shows a particularly flowing style of brushwork, and its color effect is quite remarkable.

18. *Narrow-necked hexagonal bottle; rock and chrysanthemum design. H. 23.3 cm. Saga Prefectural Museum.*

This narrow-necked hexagonal bottle with a graceful underglaze cobalt and polychrome enamel decoration shows the Kakiemon style at its very best. The design is of delicately painted rock-and-chrysanthemum and rock-and-plum motifs extending around the six curving sides of the bottle. A similar example exists in the National Museum of Dresden.

19. *Narrow-necked square bottles; plum and chrysanthemum designs. Left, H. 21.5 cm. Kakiemon Collection.*

The shape of these bottles is based on Western silver and pewter forms, and were made to order for export. The sides are somewhat conventionally painted with plum and chrysanthemum sprays as well as with flowering plants of spring and autumn. Copies of such pieces were made at the Meissen porcelain factory.

20. *European copies of Kakiemon style polychrome overglaze enameled wares. H. 1.8–11.8 cm, D. 5.1–22.5 cm. Saga Prefectural Museum.*

Hizen porcelain began to be copied at Meissen, Germany, from around 1710. The Kakiemon style was especially frequently copied, and by the end of the eighteenth century Kakiemon copies were being manufactured at the French royal pottery, Chantilly, Chelsea and Worcester in England, and also in China.

21. *Dish; grape and squirrel design. Meissen porcelain. D. 20.5 cm.*

Augustus II the Strong (1670–1733), king of Poland and elector of Saxony, was keen on Oriental porcelain. It was the Meissen ceramic factories under his rule that were the first in Europe to succeed in making true porcelain, in around 1710, and marvelous imitations of the Kakiemon style were produced at the Meissen factory.

22. *Foliate bowl; pine-bamboo-plum design and border band with floral pattern. D. 17.1 cm. Idemitsu Museum of Arts.*

The flower shape of this deep bowl, different in effect from earlier angular bowls, is very much in the European taste and is reminiscent of baroque art forms. The rim of the bowl has been painted with iron, while its inner lip has an undulating band of Indian-style *yoraku* ("stringed jewels"). The outside bears an extremely decorative but somewhat severe design of rock and pine-bamboo-plum.

23. *Jar; flower-and-bird designs in three panels. H. 25.9 cm. Idemitsu Museum of Arts.*

This masterpiece, though flavored with a certain decorative European mood, retains the feeling and grace of the Kakiemon style. Bands of chrysanthemum flowers and blue floral scrolls divide the body of the jar into three panels, each of which shows birds, peonies, and chrysanthemums above a rock. The decoration is impressive for its dynamic yet delicately drawn design, while the milk-white background of the porcelain body has a polished warmth.

24. *Lobed dish; rock and autumn grasses design. 21.2 cm x 18.4 cm. Mid-Edo period. Tanakamaru Collection.*

The unusual form of this lobed shallow dish suggests that it was one of a set of five or ten made to special order in Japan. The design of rock and flowering autumn grasses, placed a little left of center, was probably inspired by an album of designs published during the mid-Edo period. The inner surface of the dish is mostly undecorated, since it is to be used as a food vessel. The underside bears a flower-and-bird design in cobalt blue underglaze and shows the character *fuku* ("good fortune") within a double-framed square.

25. *Bowl; chrysanthemum and peony design with openwork border of linked circles. D. 25.8 cm. Idemitsu Museum of Arts.*

An order book preserved in the Kakiemon family records contains a sample sketch of a bowl with openwork linked circles. The bowl in question was probably made in a mold, with the pattern of linked circles traced on the clay from a stencil, and the openwork pattern cut out when the clay became leather hard. The fancy bowl pictured appears to have been intended for use as a cake dish. The center is decorated with a flowering chrysanthemum spray, surrounded on three sides by rocks and peonies.

26. *Pair of narrow-necked bottles; brushwood fence, flower, and bird design. Left, H. 25 cm.*

These fine bottles have long, narrow necks (known as *tsurukubi,* or "crane necks") terminating in small mouths. The neck of each, from the shoulder to the mouth, is decorated with chrysanthemum flower petals in cobalt underglaze. The enamel decoration on the tall, gently curving bodies evokes the mood of a Zen painting in the way in which it combines a brushwood fence, a plum tree, and a bird.

27. *Bowl; plum and flowering grass design. D. 26 cm.*

This bowl is an important early example of Kakiemon ware. The porcelain clay has not yet achieved the milk-white quality of later wares, iron specks have remained in the surface of the glaze, and the shape of the vessel is not regular. In later wares, overglaze enamel decorations were not painted on such poor clay, but this sort of unrefined clay body was used during the early period of Kakiemon. Bowls of this kind have the inner surface painted with a chrysanthemum spray, or occasionally with a rock and chrysanthemum or rock and peony motif, and the outside with floral scrolls.

28. *Rectangular bowl; dragon and phoenix design. H. 5 cm.*

Hizen enameled porcelain includes many fine, if unusual, pieces that cannot easily be classified as either purely Imari or purely Kakiemon in style. Among the masterpieces from the mid-Edo period are some produced at the Kakiemon workshops in the Ko Imari style according to what is known as the "Shibuemon taste" (Shibuemon is thought to have been a sixth-generation Kakiemon potter, producing wares that harmonized form and design to perfection). This bowl, with its elaborately painted cloud and dragon and floral scroll designs, has particularly attractive and flowing brushwork and great dignity.

29. *Incense burner; floral scroll design. H. 15 cm.*

From the mid- to late Edo period, Kakiemon wares were made in a wide variety of shapes, with molded pieces appearing in addition to wheel-thrown shapes. Strangely shaped pieces such as lidded vessels, incense burners, writing utensils, and alcove ornaments were manufactured in response to domestic demand. This particular incense burner has been decorated in flowing brushwork with a finely drawn blue underglaze floral scroll and red enamel.

30. *Incense burner; maple leaf and stream design. Wagtail-shaped incense box. Left, H. 6.4 cm. Mid-Edo period.*

The incense burner is decorated on the "front" and "back" with a design of maple leaves floating in a stream. The neat, compact composition of the design echoes the form of the modest-sized bowl with three feet. It is painted in light colors accentuated by a small amount of red for the leaves. The wagtail-shaped incense box is somewhat different in age, but it is richly elegant despite being small.

31., 32. *Footed rectangular dish; pine-bamboo-plum design. 21.8 cm x 9.5 cm.*

This dish is rare among extant Kakiemon tableware. It belongs to a complete set of five, and is an excellent press-molded piece from the mid-Edo period. It was apparently made for use at ceremonial banquets on certain annual festive occasions, perhaps as a dish for *ayu* (sweetfish). The brushwork of the rock and trees is firm, and the border band of floral scroll and dragons chasing pearls is painted in flowing strokes. The exterior sides are decorated with sparsely scattered maple leaves. The dish was probably part of the tableware used by a daimyo's family.

33. *Dish; flower-and-bird design. D. 18.5 cm. Kamachi Collection.*

A dish identical in form and decoration exists in the collection of the Dresden Museum. The center shows a compact flower-and-bird design in underglaze cobalt alone. The border band is divided into two separate compositions of rock-and-plum-tree and rock-and-flowering-grasses, in cobalt underglaze blue and overglaze enamels. The Western-style flowering grasses design is particularly interesting.

34. *Wall tiles; dragon design. Each tile 24.7 cm². Early Edo period. Repository, Nishi-Honganji Temple.*

Illustrated here are some of the tiles covering the lower part of the walls in the Tenrinzō (repository of Buddhist scriptures) at Nishi-Honganji Temple in Kyoto. In an excellent state of preservation, the 312 tiles are painted alternately with dragons and mythical birds. The tiles are inscribed in ink on the back, reading "By Doi Genzaemon at Arita Sarayama in Nishi-Matsuura," and also bear ink inscriptions of the names of their donors living in Saga province. Whether they were made at a workshop directly affiliated with

the Kakiemon kiln or whether Genzaemon—a man closely associated with the Sakaida family—commissioned them from the Arita Sarayama workshop remains unclear. The Tenrinzō was built in 1677 during the time of the temple's fourteenth abbot, an important fact in dating the tiles.

35. *Tile; rock and bird design. 18 cm x 17.7 cm. Tanakamaru Collection.*

It was probably during the early Edo period that stoneware and porcelain tiles began to be used for lining walls in Buddhist sanctuaries and sutra repositories, as well as in bathrooms, and so on. There are some stoneware tiles in the Oribe style, but for porcelain tiles, the Kakiemon style appears to be dominant. Unlike those shown in the preceding plate, the one shown here is in a genuine Kakiemon style. The fact that the porcelain body still has a slight amount of iron in it suggests a date even earlier than that for the tiles in Plate 34. A flower-and-bird motif has been dynamically drawn in a style reminiscent of the mural painting of the Kanō school in the early Edo period. The rock is almost cubist in effect, while the peony and birds are executed in free-flowing brushstrokes. The feathers of the two birds, the peony flowers, and the veins of the leaves are extremely elaborate; and the blue of the rock and the red of the birds and flowers make a splendid color contrast.

36. *Two-tiered lidded box in the shape of an insect cage; flowing plant design. H. 19.5 cm.*

One- or two-tiered covered boxes in the shape of insect cages may be found among Ko Kiyomizu pieces from Kyoto, and are occasionally—although very rarely—found among Imari wares. Covered boxes of this kind are generally classified by size into large, medium, and small types. The piece here is large. Opinions differ as to the purpose of such boxes, some believing that they were used by young ladies of daimyo families. The insect-cage shape also exists in *maki-e* gold lacquer ware. The idea of making two-tiered boxes in porcelain was probably inspired by the social trends of the mid-Edo period. This one has three legs, the lower tier being decorated with a series of morning glory flowers, and the upper tier with stylized floral scrolls. The lid is decorated with a net pattern, which is surmounted in relief by the tassels of the cords that come up the side of the box and are "tied" on top, the knot forming a handle. This form could easily sag or collapse in firing; it was only as a result of long training and skill of the craftsman that this pot came out of the kiln so nicely.

37. *Jar; flower-and-bird design. H. 28.7 cm.*

Covered jars of the *jinkō tsubo* form are numerous among *sometsuke* and enameled Kakiemon pots. These include some that more closely resemble pure Imari style than Kakiemon style, making them difficult to classify. There is even a pot registered by the Japanese government as an Important Cultural Property that is problematic in this respect. Clues as to the classification of such wares should therefore be sought in the decorative compositions and particularly in the contrast between the painted and unpainted areas of the design. One should also consider the treatment of the overglaze enamel decoration on the porcelain body, as well as the color tones and color combinations. The design on this jar is not divided into separate sections but is one composition, and the green of the rock and red of the flowers show deep tones, characteristics which suggest its classification as Kakiemon.

COBALT UNDERGLAZE DECORATED PORCELAIN

Sometsuke is the name given to cobalt blue underglaze decorated wares, which have a charm that the Japanese, with their special sensitivity for color, have likened to that of indigo-dyed textiles. In contrast to the brilliance of enameled porcelain, *sometsuke* porcelain displays a modest, quiet beauty.

38. Sometsuke *vase; flower-and-bird and scroll design. H. 28.5 cm. Saga Prefectural Museum.*

This vase may have been made at Mukurodani-gama in Nangawara-yama, a collateral kiln of the Kakiemon workshop. It is painted on one side with a rock and pine-bamboo-plum design, and on the opposite side with a rock, bamboo, and sparrows. The tall, slender neck has a complex design of tendril scrolls and other motifs. The cobalt pigment contains quite a lot of iron, giving it a dark, dull tone. The decoration is typical of the Kakiemon style, although it also contains Imari style elements.

39. *Large* sometsuke *bowl; rock and heron design. H. 16.7 cm, D. 42 cm. Tanakamaru Collection.*

After the Bunka-Bunsei eras (1804–1830), when domestic demand for blue-and-white porcelain increased, the Kakiemon kilns also manufactured large, deep bowls and other such popular pieces. The interior surface of this bowl is decorated in three bands: a rock and heron design at the center, a landscape with fishing nets drying in the middle, and rock-and-bamboo, rock-and-plum, and bird motifs in the top band. The linked scrolls on the exterior are drawn with powerful brushstrokes.

40. *Square* sometsuke *dish; hydrangea design. Sides 22.7 cm. Tanakamaru Collection.*

The decoration is painted in a clear-toned blue, evoking the freshness of early summer. An identical design is to be found in the *Ehon tsūhō shi* copybook. The diagonal composition in the square panel shows a fine balance of decorated and undecorated areas. Intended as a cake dish, this dish thus combines utility with beauty. The border is decorated with three bands of scrolls. The back of the dish bears the *sometsuke* mark "Saka Kaki," an abbreviation of "Sakaida Kakiemon." Apparently the dish was made at the Kakiemon kiln around the Meiwa era (1764–1772).

41. Sometsuke *fan-shaped lidded container; peony scroll and phoenix design. 23.2 cm x 15.9 cm x 6 cm. Kakiemon Collection.*

A few years ago, I saw a similar *sometsuke* fan-shaped lidded box at The Hague Municipal Museum. Such boxes were possibly made for export. They are valuable rarities, different in form and style from pure Imari work. Fine pieces of *sometsuke* like this have a profound, noble beauty quite unlike enamel-decorated porcelain. The blue lines and areas of the spreading peony flowers and phoenix are harmonious in tones and rhythm, and the brushwork is fluent and accentuated. The potter's finesse is evident in such details as, for example, the converging ribs of the fan around the pivot, which were cast in relief.

42. Sometsuke *incense burner; deer and tree design. H. 12.2 cm, D. 20 cm.*

Excellent pieces with designs of deer exist among enameled and *sometsuke* porcelain wares. Unlike Imari and Nabeshima *sometsuke*, Kakiemon *sometsuke* ware is characterized by an idyllic tenderness. The sides of the incense burner here are painted with mountains and fields in spring, with fragrant young pine trees and leaping deer. The body of this pot resembles a scroll painting that is unrolled before one's eyes. Floral scrolls decorate the rim, while the bottom of the interior is unglazed.

43. Sometsuke *dish;* ayu *sweetfish design. D. 19.3 cm. Tanakamaru Collection.*

This summer motif in free, light brushwork in blue monochrome is pure and fresh, like a Zen ink painting. The design shows an exceptionally dynamic composition. The dish was made at a kiln affiliated directly with the Kakiemon family and the workmanship is different from the products of the collateral workshops. It is one of a set of similar dishes but is sufficiently worthy of being appreciated independently.

44. Sometsuke *dish; maple and deer design. D. 18 cm. Kamachi Collection.*

This typical Kakiemon style decoration has been found on many *sometsuke* shards unearthed at old kiln sites on the hill behind the workshop of the present-generation Kakiemon. The poses of the deer are interestingly similar to those of the piece in Plate 42. A picture of maples and deer is illustrated under the title "Kasugano" (Kasuga Field) in the *Ehon tsūhō shi* copybook. It is a motif full of poetic associations and is frequently found in Japanese art. The rim has been painted with iron, which effectively enhances the simple blue decoration.

45. *Dish; Hotei and autumn flowers and grasses design. D. 24.8 cm. Tanakamaru Collection.*

Around the middle of the Edo period, woodblock-printed picture and copybooks were published throughout the country. Many of the pictures in such books found their way into ceramic ware decoration. This figure of Hotei, who is known in the West as the "laughing Buddha," may well be an example of this borrowing.

46. *Dish; sparrow and bamboo design. D. 21.4 cm. Kamachi Collection.*

The decoration on this dish, leaving ample areas of the beautiful milk-white porcelain body unpainted, shows a composition typical of the Kakiemon style.

47. *Foliate bowl; flower and butterfly design. D. 25 cm. Saga Prefectural Museum.*

This molded bowl has a precise, dignified form, while the floral scroll design in its center medallion is particularly impressive.

48. *Figurine of standing woman. H. 57.3 cm.*

49. *Figurine of standing woman. H. 35.5 cm.*

50. *Figurine of standing woman. H. 22.4 cm. Idemitsu Museum of Arts.*

Polychrome overglaze enameled porcelain ware from Hizen includes a number of figurines of women, children, actors, and other figures. Female figures in the Kakiemon style are different from those in the pure Imari style, being characterized by faces with elegant, quiet expressions similar to the masks used in the Nō theater. Kakiemon style female figures are sometimes made in the same mold, but their clothing is decorated with different designs.

51. *Octagonal* mukōzuke *dishes; grape and squirrel design. Left, 7.5 cm. Tanakamaru Collection.*

No other example of the numerous Kakiemon food small bowls for everyday use display the characteristics of the ware as well as these small bowls. The milk-white porcelain body is flawless, and the enamel decoration harmonizes with the luminous porcelain.

THE KAKIEMON TRADITION TODAY

The present head of the Kakiemon workshop, Kakiemon XIII, has tried to honor the tradition of design and technique that is his heritage, while instilling a sense of modernity in enamel decoration. Both he and his father tried to re-create the luminous milk-white porcelain body of the Edo period, the techniques of which had been lost for some time. Kakiemon XIII also experiments with novel designs based on his studies and sketches of wild plants.

52. *Dish; flowering grasses design, by Kakiemon XIII. D. 45.6 cm.*

Edo period enameled Kakiemon pieces decorated with sprays of wild plants are very rare. Kakiemon XIII knows that large bowls with a milk-white porcelain body frequently fail in the firing, yet he is daring enough to experiment in this field. A man of less rigid

sobriety than his father, he likes to play the samisen and sing amorous ballads when drinking. It is this sort of mind that probably enables the creation of such ideas as the generous design on this dish. The design recalls a bundle of flowering grasses placed on a large lacquer tray, while leaving much unstated. Particularly notable is the balance between the areas of the enamel decoration and the beautiful milk-white porcelain body.

53. *Large dish; flowering grasses design, by Sakaida Masashi. D. 40.3 cm.*

This artist, the only son of Kakiemon XIII, is still young; for this reason, perhaps, he can work in a liberal and unrestricted style. Precisely because he belongs to a strongly conservative family, I look forward to the development of his designs. Masashi learned the orally transmitted secrets of overglaze enamel recipes from his grandfather. Being modest, he follows his father's example and treats wild plants as his motifs. This design of foxtail *(Setaria viridis)* flowering on the roadside, although unrefined, is full of youthful rhythm.

伊万里と柿右衛門
CLASSIC JAPANESE PORCELAIN

2003年7月4日　第1刷発行

著　者　　永竹　威
発行者　　畑野文夫
発行所　　講談社インターナショナル株式会社
　　　　　〒112-8652　東京都文京区音羽 1-17-14
　　　　　電話　03-3944-6493（編集部）
　　　　　　　　03-3944-6492（営業部・業務部）
　　　　　ホームページ　www.kodansha-intl.co.jp
印刷所　　光村印刷株式会社
製本所　　牧製本印刷株式会社